CRAWSHAW *paints* CONSTABLE *Country*

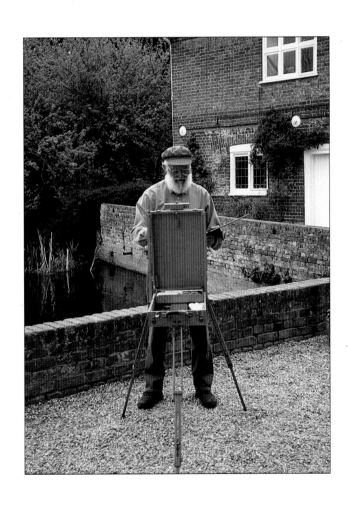

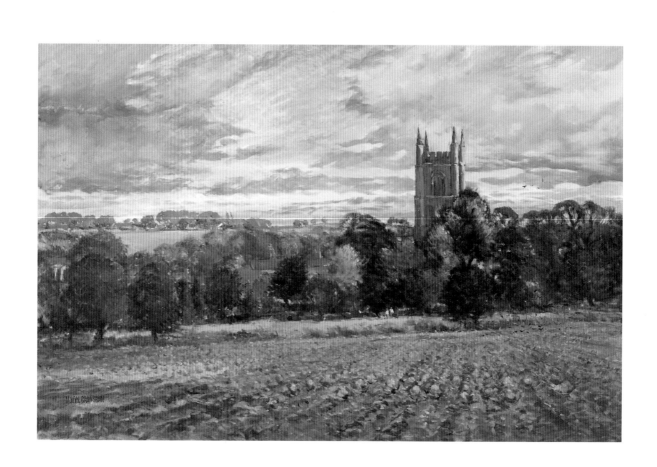

CRAWSHAW *paints*
CONSTABLE
Country

ALWYN CRAWSHAW

HarperCollins*Publishers*

in association with
Anglia Television Limited,
Channel Four Television Corporation
and David John Hare

DEDICATION

I would like to dedicate this book to June, my wife, and also to express my thanks for her unfailing help and support during the filming of the series, this time from behind the television cameras.

The quotations in this book are reproduced with the kind permission of Phaidon Press Limited from *Memoirs of the Life of John Constable* by C R Leslie, first published in 1980.

The 6-part television series, *Crawshaw Paints Constable Country*, was produced and directed by David John Hare of J. R. Productions for Anglia TV and Channel 4. Videos of the series are available from Teaching Art Ltd, PO Box 50, Newark, Nottingham NG23 5GY; telephone 01949 844050.

First published in 1996 by
HarperCollins*Publishers*, London

© Alwyn Crawshaw, 1996
Constable paintings © individual galleries

Editorial direction: Cathy Gosling
Designed, edited and typeset by Flicka Lister
Photography: Nigel Cheffers-Heard
and June Crawshaw
Maps: Steve Munns

Alwyn Crawshaw asserts the moral right to be identified as the author of this work.

A catalogue record for this book is available from the British Library

ISBN 0 00 413304 8

Colour reproduction by Saxon Photolitho, Norwich, UK.
Printed and bound by Bath Press, Bath, UK.

CONTENTS

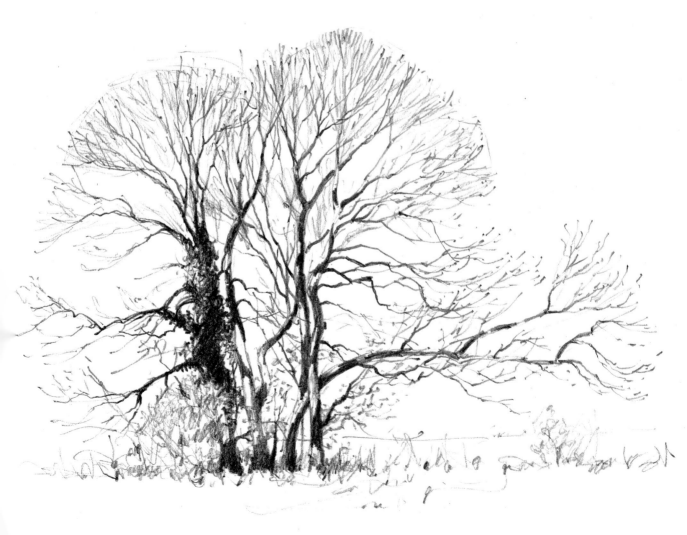

FOREWORD

John Constable was born in East Bergholt in Suffolk on 11 June 1776, the fourth child of Golding Constable, a wealthy corn merchant who owned land, boats, windmills, Dedham Mill in Essex and Flatford Mill in East Bergholt. The village plumber and glazier, John Dunthorne, was the first person to teach Constable to draw and his enthusiasm for art was further stimulated by Sir George Beaumont, an amateur painter whom he met in 1795.

When it became obvious that John Constable wasn't going to fulfil his parents' initial wish and join the clergy, his father trained him to become a miller. However, this also proved fruitless, and so he was allowed to enrol as a probationer at the Royal Academy school in London in 1799.

STRUGGLING ARTIST

In 1802 Constable exhibited at the Royal Academy for the first time and bought a cottage studio in East Bergholt. Because England was at war with France intermittently during this time, Constable couldn't follow in the footsteps of earlier artists on the Grand Tour of Europe, even if he had wanted to. He frequently returned from London to what became known, even in his lifetime, as 'Constable Country' and in 1809 fell in love with Maria Bicknell, granddaughter of Dr Rhudde, the rector of East Bergholt. Her family wasn't impressed by the prospects of the still-struggling artist and the couple had a long and frustrating courtship until they finally married in 1816. Sadly, their marriage was only destined to last 12 years. Maria, whose health had always been delicate, died of tuberculosis in 1828 after bearing Constable seven children.

Constable painted some of the best-known pictures of the English countryside and is partly responsible for creating an image of England as a bucolic, rural idyll, basking in endless summer sunshine. 'The Hay-wain' has been reproduced on everything from tablemats to thimbles and, like many people, I used to think that Constable's pictures were 'chocolate-boxy'. However, while making the television series, *Crawshaw Paints Constable Country*, it quickly became clear to me that John Constable was a revolutionary in his time. This idea may be hard to grasp when you see 'The Hay-wain' on a box of fudge, but in those days Constable was breaking an artistic mould. Sketching outdoors in pencil, oil and watercolour, he captured the atmosphere and the feel of nature in a novel and convincing way. While aiming at truth, he also used artistic licence but his paintings weren't full of classical imagery like those of his contemporaries.

Looking at the incredible detail in Constable's exhibition paintings, it is hard to imagine his work being criticized for not being 'finished' enough. By the standards of his day, his pictures weren't immaculately polished but this is only because he was painting what he saw, and the natural world isn't neat and tidy. Once I realized this, I saw his work in a completely different light. 'The Hay-wain' isn't some cleverly-created image, cynically designed to appeal to our fantasies of rural bliss, but a picture of a real event, albeit recreated in his London studio. Constable's own title for the picture was 'Landscape: Noon' – not a very romantic one.

Constable was anxious to be taken seriously by the English art establishment but failed to be elected to the Royal Academy for many years. He

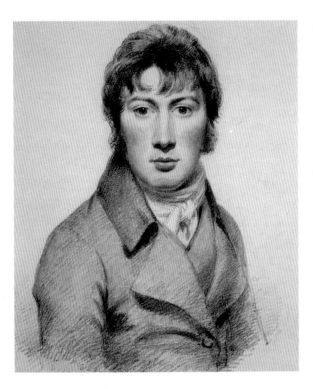

Self-portrait. *Constable c.1800*
Pencil and chalk 24.7 × 19.5 cm (9¾ × 7⅛ in)
By courtesy of the National Portrait Gallery, London

was 43 before he was made an Associate and it was another ten years before he was elected a full Royal Academician. He did attract admirers abroad, however. King Charles X of France awarded him a Gold Medal in 1824 after 'The Hay-wain' had been exhibited in the Paris Salon and, as this was only nine years after the Battle of Waterloo, it shows how highly the French regarded him. Delacroix called him the 'father' of modern French landscape, and Constable can be seen standing in a line that leads to and beyond Impressionism.

The fact that Constable painted from nature should not in any way detract from his skill, success and continuing popularity. He was a professional artist who worked hard, took commercial decisions, and studied nature intensely. The conflict between his declared artistic intentions and what was required to become a success professionally makes his work all the more interesting. In addition, it is worth remembering, he had to earn enough money to look after his seven children and a sick wife.

The television series which accompanies this book was filmed entirely on location in Constable Country, an area of about twelve square miles on the Suffolk-Essex border. In the 160 years since John Constable's death it has remained incredibly unspoilt and it is easy to imagine what he saw while walking on his way to school, or as he fished in his father's mill stream. All the Constable paintings featured in the series were painted outdoors by him, or are scenes of the area, painted later back in his studio in Hampstead, London. In some instances, where we feature a painting done in the studio, we also show a sketch of the same subject that he would have completed on location.

ENJOYMENT OF ART

Having written exclusively about Constable so far, I would like to say something about Alwyn Crawshaw. He would not like me to make any comparison between himself and Constable – two individual and quite different artists – but both of them have popularized landscape painting and given huge enjoyment and pleasure to millions of people. We are lucky enough to go to some wonderful locations when filming television series, including some very remote spots, and I am always amazed by the amount of people, no matter where we are, who recognize Alwyn and, more importantly, enjoy his paintings. I suspect that for both Alwyn Crawshaw and John Constable, painting is and was primarily about enjoyment.

I hope that both this book and the television series encourage you to visit Constable Country and to look afresh at the wonderful works of art that it has inspired.

David John Hare
Producer and Director
Crawshaw Paints Constable Country

AUTHOR'S NOTE

One of my most vivid memories from my art school days in Hastings is of my first trip to London to the National Gallery. I went there with a friend to see 'The Hay-wain' by John Constable. He was, and still is, one of my favourite painters and at art school he was my inspiration. In fact, the first paintings that I can remember, even before going to art school, were his. Naturally, they were reproductions but, above all others, his landscapes held a magic for me. This was the kind of painting I wanted to aspire to. Constable once said: 'The landscape painter must walk in the fields with a humble mind. No arrogant man was ever permitted to see nature in all her beauty', and for me this honest sentiment shines out of all his paintings.

In the early 1970s I made a sketching and painting pilgrimage to Constable Country and I can still remember the wonderful feeling of seeing the landscapes that had been immortalized in Constable's paintings, like Willy Lott's cottage and Flatford Mill, for the very first time. Since then I have been drawn back to the area and it has become one of my favourite places, not just because Constable loved it so much but because it is full of marvellous locations for the landscape painter.

The thought of doing a television series in Constable Country, and painting the areas where Constable found the inspiration for some of his most famous works, excited me as much as that first time I stood in front of the painting of 'The Hay-wain' at the National Gallery, when I was just 16 years old. Of course, neither the television series nor this book can begin to do justice to the immense variety of Constable's work. He also painted in London, the Lake District, Salisbury and Brighton, amongst other places. This is not an in-depth academic study of his life and works, as many excellent books have been published on this subject. I have written it from my own viewpoint, as a working artist, about an artist, for people who are interested in painting themselves, or who would like an interesting introduction to John Constable, the landscape painter.

The book follows the television series as I journey down the lanes and across the meadows that Constable once walked and painted. I have indicated on local maps in each chapter, with a blue viewpoint symbol, the places where Constable painted some of his famous pictures, and also where I painted, either for television, or the book.

I learned many things about Constable and his life during my research and was particularly interested to find out that his ancestors came from Yorkshire (where I was born) and that he enjoyed fishing (my favourite pastime).

Constable Country is amazingly unspoilt, having changed little over the last 200 years. If you have the chance to visit the area and, like me, follow in Constable's footsteps, I am sure that you will have a wonderful time there, as I always do.

Alwyn Crawshaw

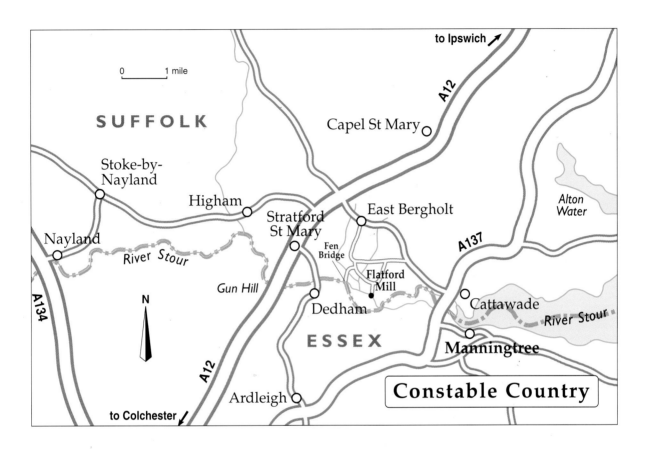

PROGRAMME 1
INTRODUCTION

'Still I should paint my own places best ... I associate "my careless boyhood" with all that lies on the banks of the Stour; those scenes made me a painter ... that is, I had often thought of pictures of them before I had ever touched a pencil.'

John Constable

~

My journey through Constable Country started at the site of his father's home, where John Constable was born. The house, a large property, had a commanding position in the centre of the village of East Bergholt in Suffolk. Now only a plaque marks the spot – sadly, after Constable's death, the house was badly damaged by fire and eventually pulled down. However, he did various sketches and paintings of the house and one of them, 'East Bergholt House', is reproduced opposite.

Near the site of the original building another one was built using bricks from the demolished house and I was lucky enough to be invited by the present owners to wander around the flower garden where Constable would have played as a child. A lovely mellow red brick wall runs down the side of the garden and this is the same one that is seen on the left of Constable's painting, 'Golding Constable's Flower Garden', shown below right. Constable painted this view from a window on the top floor of his father's house.

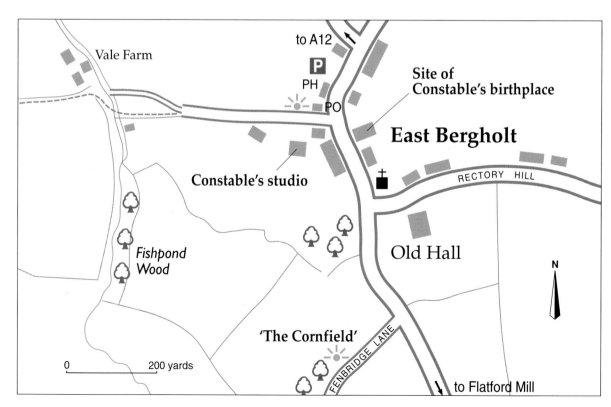

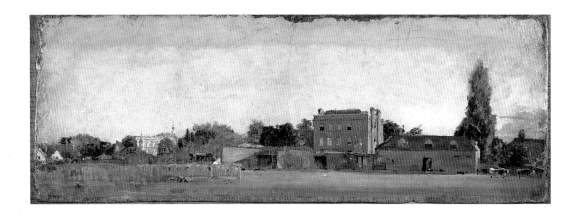

East Bergholt House. *Constable c.1809 Oil on board laid on panel 18.2 × 50.2 cm (7⅛ × 19¾ in)*
By courtesy of the Board of Trustees of the Victoria & Albert Museum, London

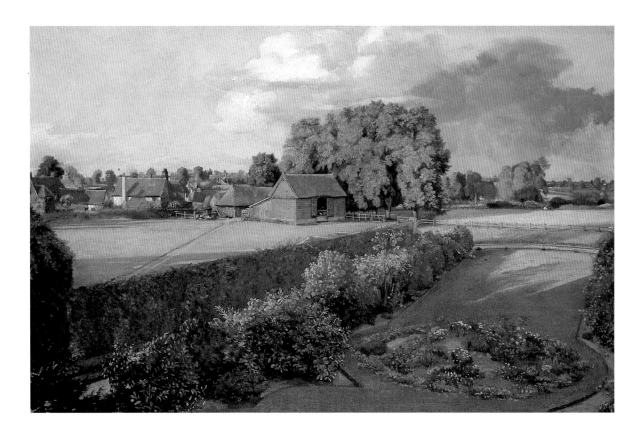

Golding Constable's Flower Garden. *Constable 1815 Oil on canvas 33 × 50.8 cm (13 × 20 in)*
Ipswich Borough Council Museums and Galleries

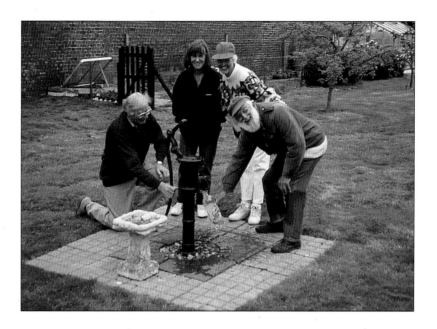

ABOVE: *A happy moment filling up my lemonade bottle with water from Constable's well.*

The best was yet to come. My hosts pointed out the old water pump in the garden and told me that this was the one from which the Constable family had drawn all their water. Remarkably, it still works today and I am now the proud owner of a lemonade bottle full of water from the well that Constable used. It is a wonderful memento and sits in a prominent place in my studio.

CONSTABLE'S STUDIO

Across the road from the house is the small cottage which Constable used as a studio. Although it now forms part of a garage, it is kept in very good condition. In fact, very little has changed in East Bergholt since Constable's day. His friend and first painting tutor, John Dunthorne, had a shop in the village and this still survives. Incidentally, Dunthorne was a very controversial figure. An atheist, he even advertised in a newspaper to find his wife. Constable, who came from a very conventional background and wanted to marry the local rector's granddaughter, must have found this friendship awkward when he started courting, and he and John Dunthorne eventually became estranged.

Other buildings of the time still remain in the village and, standing in front of the artist's old studio, it wasn't difficult for me to imagine Constable coming back from a morning's sketching in the meadows and going through the doorway! For a moment, the mechanical noises from the garage next door faded away to be replaced in my imagination by the clatter of carts and horses' hooves from Constable's day...

However, I had to move swiftly back to the present. I had decided that my first sketch of the series would be one of Constable's studio and the television crew were waiting for me to start!

I did the pencil sketch standing in the middle of the road, with quite a lot of interruptions to let traffic pass. But what a wonderful way to start the series, sketching the place where Constable did so much of his early work. I was surprised that I was capable of drawing a straight line, with my mind wanting to wander off into the past!

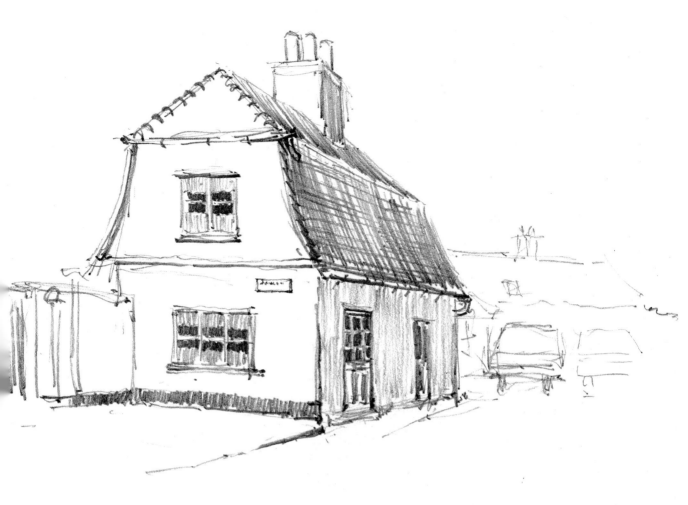

ABOVE: **Constable's studio, East Bergholt.** *Alwyn Crawshaw*
Pencil on cartridge paper, 20 × 28 cm (8 × 11 in)

Before I began sketching Constable's studio, there were some important features to consider. These were the big chimney stack, the large ridge tiles and the unusual shape of the end elevation. Always observe the character of your subject very carefully before you start drawing. Notice that I suggested a couple of cars in my sketch to bring things up to date.

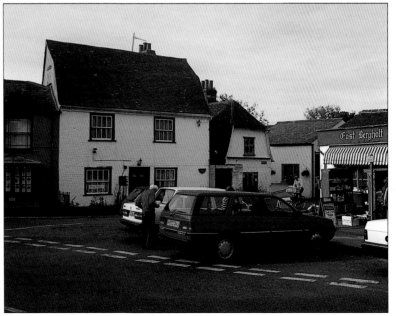

ABOVE: *The view today of Constable's old studio, which now forms part of a working garage.*

A short walk from Constable's studio is Fenbridge Lane. As a schoolboy, he walked down this lane every day before crossing the meadows to Dedham on his way to the Grammar School. These walks were a very informative time for him and Constable often said that the scenes of his 'careless boyhood' made him a painter.

OBSERVING NATURE

Standing in Fenbridge Lane, I understood what Constable meant. When I was 15 years old, I did a paper round every morning before going to art school to help pay for my art materials. Walking down similar lanes delivering the newspapers to houses deep in the Sussex countryside, I saw the countryside in all its wonderful moods and would be bursting with enthusiasm to paint by the time I got to art school.

Fenbridge Lane is still a typical English country lane and scholars believe that this is where Constable got the inspiration for one of

his most famous paintings, 'The Cornfield', shown right, which was painted in his London studio. The hedgerows have changed with time but the stream from which the boy is drinking on the left of the painting still remains, although nowadays it is more of a ditch than a stream.

When 'The Cornfield' was first exhibited at the Royal Academy in 1826, no one bought it and it remained unsold for 11 years. I worry if I don't sell a painting in six months, but I won't now! Eventually a group of 100 subscribers, including the poet Wordsworth, bought it for £315 and gave it to the National Gallery, where it can still be seen today in all its glory. Do go there if you get the chance – the only way to appreciate Constable's paintings fully is to see them, not as reproductions, but in the original.

Fenbridge Lane is so untouched by modern times that, again, it was very easy to imagine I was sketching back in Constable's day. I did the pencil sketch, below, looking back up the lane in the direction of East Bergholt.

LEFT: **Looking up Fenbridge Lane, East Bergholt.** *Alwyn Crawshaw 2B pencil on cartridge paper, 28 × 20 cm (11 × 8 in)*
I sketched this view of the lane when I was looking for painting locations. I started by drawing in the path – the most important part of the sketch to establish. I then put in the trees. Notice how the strong shadow on the left bank helps to emphasize that the lane curves to the left at the top.

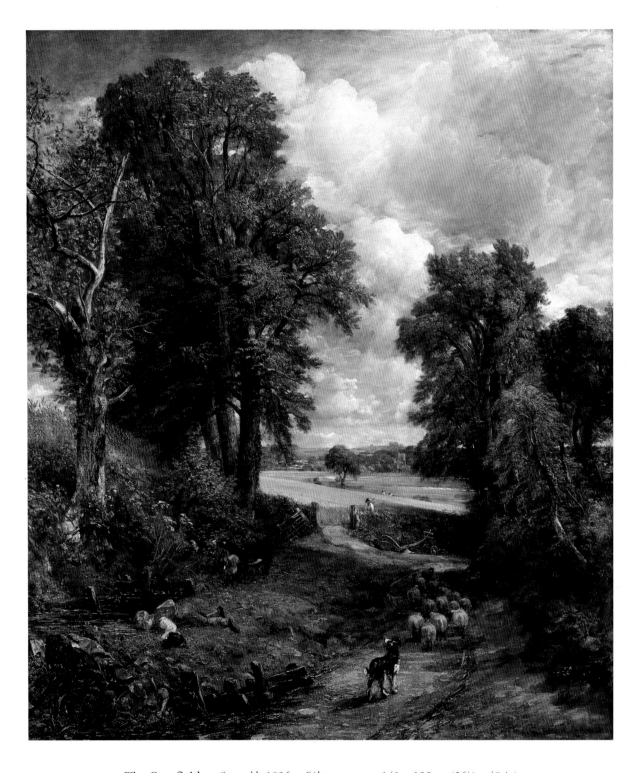

The Cornfield. *Constable 1826 Oil on canvas 143 × 122 cm (56¼ × 48 in)*
Reproduced by courtesy of the Trustees, The National Gallery, London

I decided to do a small oil sketch looking down Fenbridge Lane from the spot where it is thought that John Constable got his inspiration for 'The Cornfield'.

When I am outdoors sketching in oils, I am usually tempted to overwork a sketch and it can end up as a 'finished' painting. The best way to remedy this is to work to a time limit. This concentrates your thoughts on painting the scene quickly and means that you have to simplify things and focus on the most important elements of the scene. I completed this sketch in approximately 60 minutes, and stood at my easel to paint since I tend to put too much detail into a sketch and often finish up fiddling if I work sitting down.

FAVOURITE SEASONS

I have often wondered why Constable didn't paint winter scenes with snow. It is said that he didn't like painting autumnal scenes because he wanted to get away from the 'brown' paintings of his predecessors. In a letter to the Reverend John Fisher of Salisbury, his closest friend, he wrote in late October 1823, 'I want to get back to my easel in town, and not to witness the rotting, melancholy dissolution of the trees, which two months ago were so beautiful'. Constable painted nature as it was but, above all, he loved the spring and summer months.

ABOVE: *Painting the scene for television.*

RIGHT: **Fenbridge Lane.** *Alwyn Crawshaw*
Oil on primed hardboard with an acrylic wash of Raw Sienna, 30 × 25 cm (12 × 10 in)
The important aspects of this painting were the blue sky showing through the leaves, the green sunlit field and the way the sun was casting strong shadows on the lane. I drew in the painting first using a dark turpsy wash of Cobalt Blue, Crimson Alizarin and Yellow Ochre and my No. 4 bristle brush. Then I worked in the colour. I put the two people in last of all and, in the close-up detail below, you can see how freely they were painted.

16

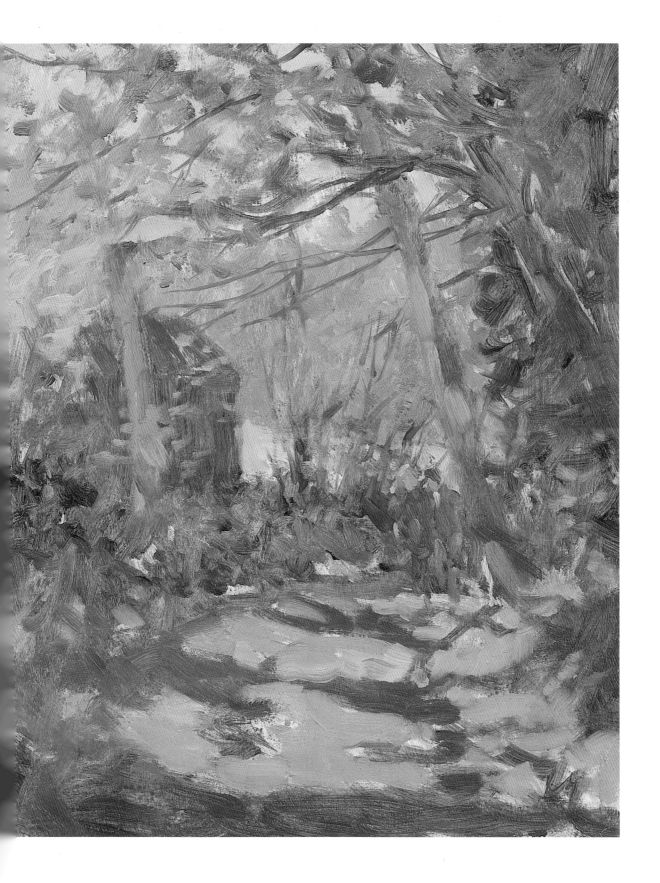

Crossing Fen Bridge, I turned left along the River Stour towards Flatford Mill. The walk to Flatford along the river is about three-quarters of a mile and takes you through some wonderful unspoilt countryside which really can't have changed much since Constable's time.

'THE HANDSOME MILLER'

Flatford Mill was owned by Constable's father and, during the year that he was being trained in the family business, Constable performed his duties conscientiously and well. He even earned the nickname in the village of 'the handsome miller' for his admirable physique, good features, fresh complexion and fine dark eyes (see his portrait on page 7).

Although his heart may not have been in his work, the time Constable spent working in the mill trade before finally being given his father's blessing to follow a career as a painter wasn't completely wasted. Millers have to keep a

watchful eye on the weather and the knowledge Constable gained about sky and cloud formations stood him in good stead in later years (see page 64).

Constable spent much of his boyhood playing and fishing around Flatford Mill and later sketched and painted many scenes of the mill and its surroundings. The knowledge he gained from all his keen observation would have also served him well. His younger brother, Abram, who eventually took over the family business, said of him: 'When I look at a mill painted by John, I see that it will go *round*, which is not always the case with those by other artists.'

Constable didn't have a camera to help him, although I am sure he would have used one if it had been invented then (see page 30). However, armed with his many sketches and his memories of Suffolk, he was always able to work on large canvases back in London.

On the edge of the river, just opposite Flatford Mill is Willy Lott's house, also known as Willy Lott's cottage. This building has become world-famous through Constable's paintings and appears in 'The Hay-wain', right, which was exhibited at the Royal Academy in 1821. Like 'The Cornfield', this was painted by Constable at his Hampstead studio.

THE REAL THING

'The Hay-wain' is possibly the best-known painting in England. It has been reproduced countless times on everything from chocolate boxes to tea towels but often these reproductions are not faithful to the original.

Once again, I would urge you to see the full-size painting in the National Gallery in London if you can – then you will be able to appreciate wonderful details like the person fishing by the boat on the right and, way in the distance, the hunched figures of mowers in the hay field. In fact, every time I look at 'The Hay-wain', I see something new.

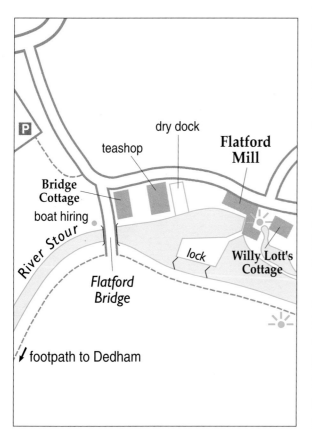

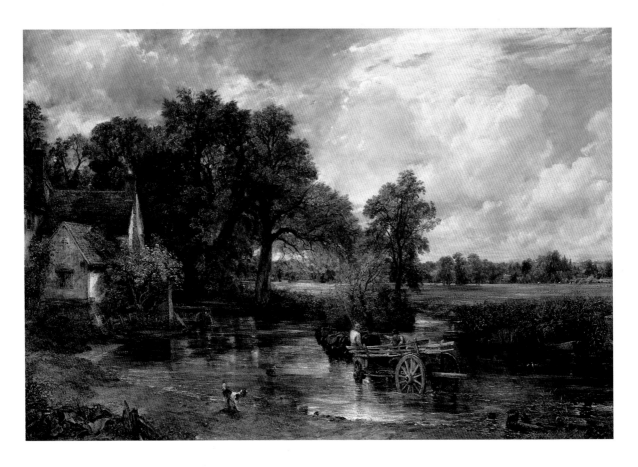

The Hay-wain. *Constable 1820–1 Oil on canvas 130.5 × 185.5 cm (51¼ × 73 in)*
Reproduced by courtesy of the Trustees, The National Gallery, London

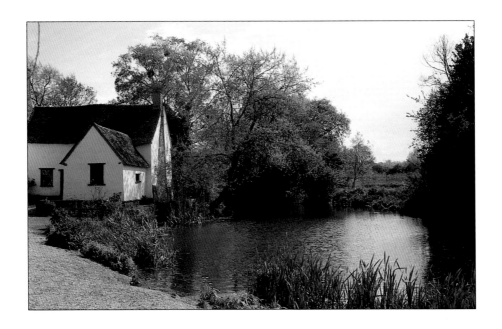

The view that inspired Constable to paint 'The Hay-wain', as it is today.

Constable painted the oil sketch of Willy Lott's cottage, opposite, some seven to ten years before 'The Hay-wain'. This was done from a different viewpoint and Constable would have stood on the forecourt of Flatford Mill looking over the brick parapet which runs along the edge of the forecourt. I love the freedom of the brush strokes and the richness of colour and sunlight in this sketch. It shows the size of Willy Lott's house, which was large for a farmhouse in those days.

THE STORY OF WILLY LOTT

Willy Lott was a local farmer whom Constable knew very well. He lived in the house for 80 years and is said to have only been away from it for four days during his entire lifetime! When Willy Lott died, Constable's brother, Abram, tried to buy the house to make it part of the mill complex, but felt the price was too high, and so it never belonged to the Constable family, although it remained a favourite subject for Constable to paint.

Today Willy Lott's cottage, together with Flatford Mill, the Mill House and the adjoining grounds are kept in remarkably good condition by the National Trust and the Flatford Mill Field Studies Council, an independent educational charity for increasing environmental awareness. Due to their excellent care, the buildings and surrounding area look very much as they would have done in Constable's day.

I decided to do a watercolour painting (shown on page 22) of the cottage from the forecourt of the mill. It may even have been from the same spot that Constable chose to do 'The Mill Stream', opposite. It certainly felt exciting being where the Master had worked – almost as if I were putting myself in his shoes!

BELOW: **Quick sketch, Willy Lott's cottage.**
Alwyn Crawshaw
2B pencil on cartridge paper, 17 × 28 cm (7 × 11 in)
I did this sketch while I was waiting to be photographed. It only took a few minutes but I thoroughly enjoyed doing it.

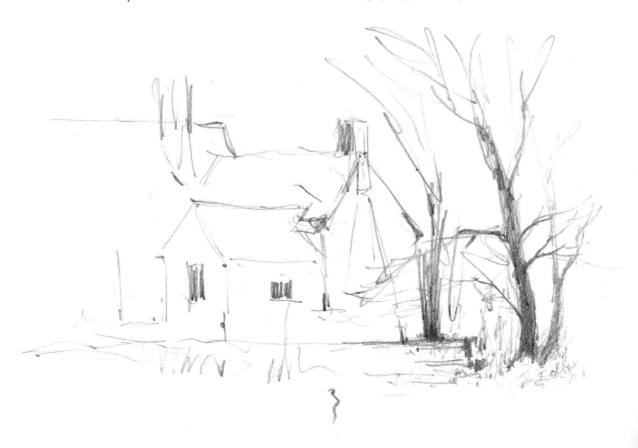

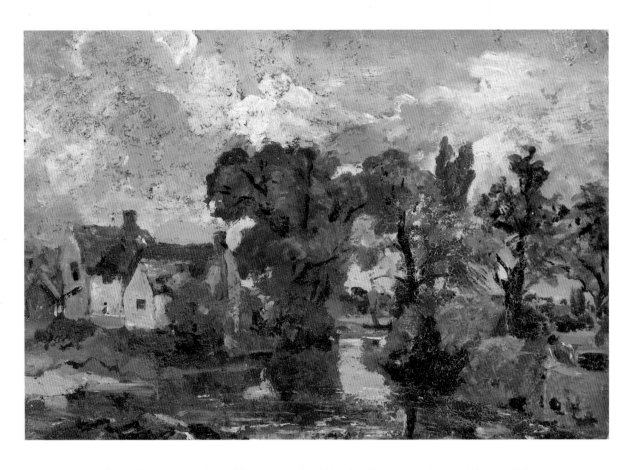

The Mill Stream. *Constable c.1811–14 Oil on board 20.8 × 29.2 cm (8³⁄₁₆ × 11½ in)*
Tate Gallery, London

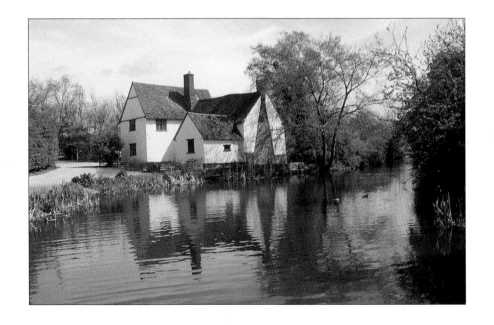

Willy Lott's cottage as it is today.

RIGHT: **Willy Lott's cottage from the forecourt of Flatford Mill.**

Alwyn Crawshaw

Watercolour on cartridge paper,

28 × 43 cm (11 × 17 in)

I felt that the most important aspects of this painting were the water and the reflections showing in it. If I went wrong here, I knew that the painting wouldn't be a success.

I painted the sky first and, when this was dry, I put in the trees, the roofs and finally added a dark wash on the shadow side of the cottage. I left the sunlit areas of the cottage as white, unpainted paper.

Now there was no turning back – the water had to be done! I mixed three washes: one for the greeny reflections, another for the reflection of the shadow side of the cottage and one for the reflection of the red roofs. Then I loaded my large brush and worked from left to right with 'wavy' horizontal brush strokes, changing the colours where necessary and adding blue as I reached the foreground.

When this was dry, I painted over it with a darker wash in short, 'wavy' horizontal brush strokes. This helped to give movement and sparkle to the water.

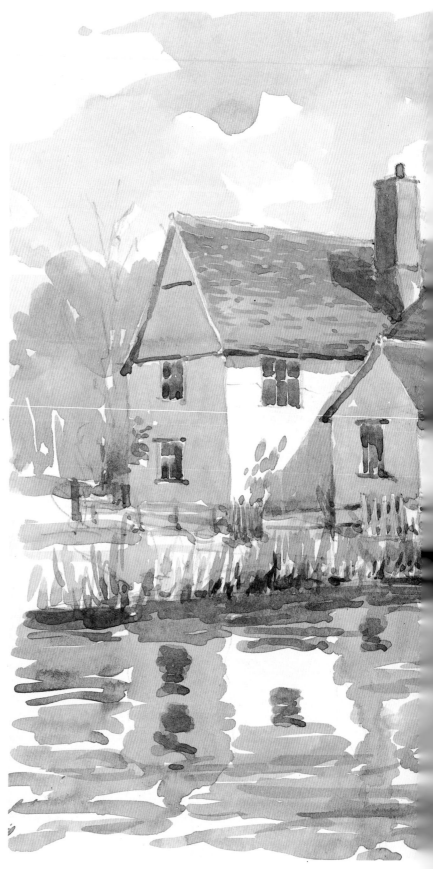

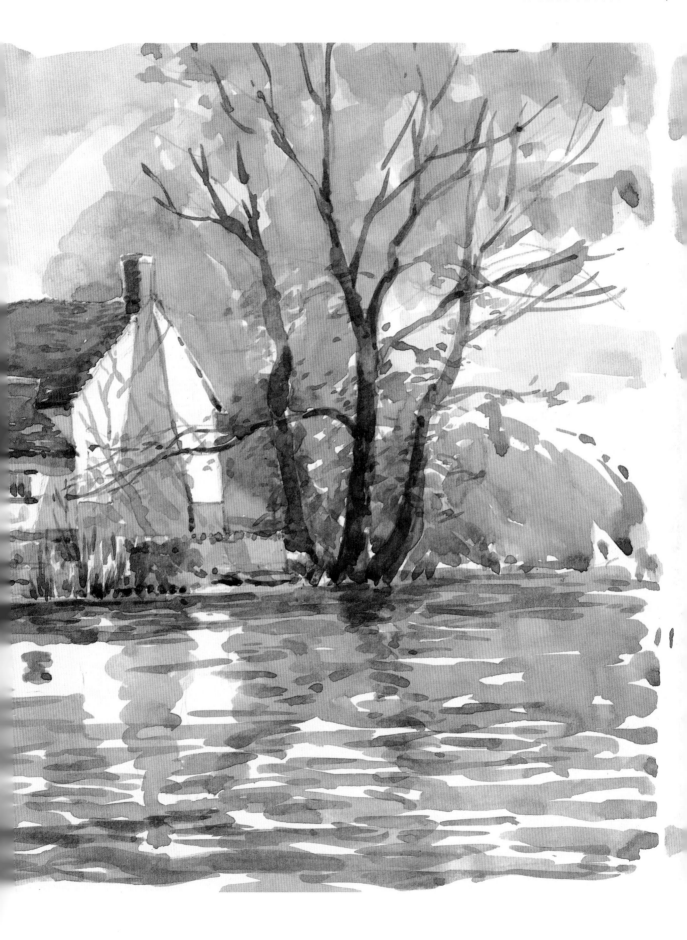

When we were looking for locations for the television series, I did a pencil sketch of Willy Lott's cottage and also took some photographs. However, this time I sketched the cottage from the opposite bank. In fact, I was standing almost at the spot where the wagon in 'The Hay-wain' would have come out of the river before it carried on into the field.

It was late autumn and the riverbank was full of young trees and undergrowth. The scene looked absolutely fantastic because the shadows from the trees were making dappled shapes on the heavily sunlit side of the house.

FIRST IMPRESSIONS

Back in my studio in Dawlish, I painted the scene in acrylic (shown right) using my pencil sketch, my memory and photographs to help me. When you do a painting in the studio rather than working on the spot, it gives you more time to consider and change things and, of course, you shouldn't be afraid to do this if it improves your painting. However, don't lose sight of what you set out to achieve in the first place and what inspired you.

I really enjoyed doing this painting and feel I managed to get the impression of the sunlight on the cottage and in the trees. This was what captured my imagination when I did my original pencil sketch.

A PERFECT VIEW

Incidentally, when we came to do the filming, the trees and undergrowth on the bank I had painted from had been cut down and levelled. I couldn't understand why until we looked at the view from Constable's painting position for 'The Hay-wain'. For the first time, I saw the opening on the far side of the mill stream. It was a wonderful idea of the National Trust and the Flatford Mill Field Studies Council so that people could see and recognize the exact view that Constable painted in 'The Hay-wain'.

RIGHT: **Willy Lott's cottage from the right-hand bank of the River Stour.** *Alwyn Crawshaw*
Acrylic on canvas, 91 × 60 cm (36 × 24 in)
I painted the cottage a warm white and carefully added the delicate shadows which were cast over it by the trees. I used a lot of small brush strokes in the trees, continually changing colour and tone and this helped to give them variety and movement. Notice how I have kept the foreground dark in tone. This contrasts with the lighter sunlit areas and helps to give the impression of sunlight in the painting.

In the close-up detail, below, notice how the shadows cast by the trees fall onto the side of the roof and the cottage wall.

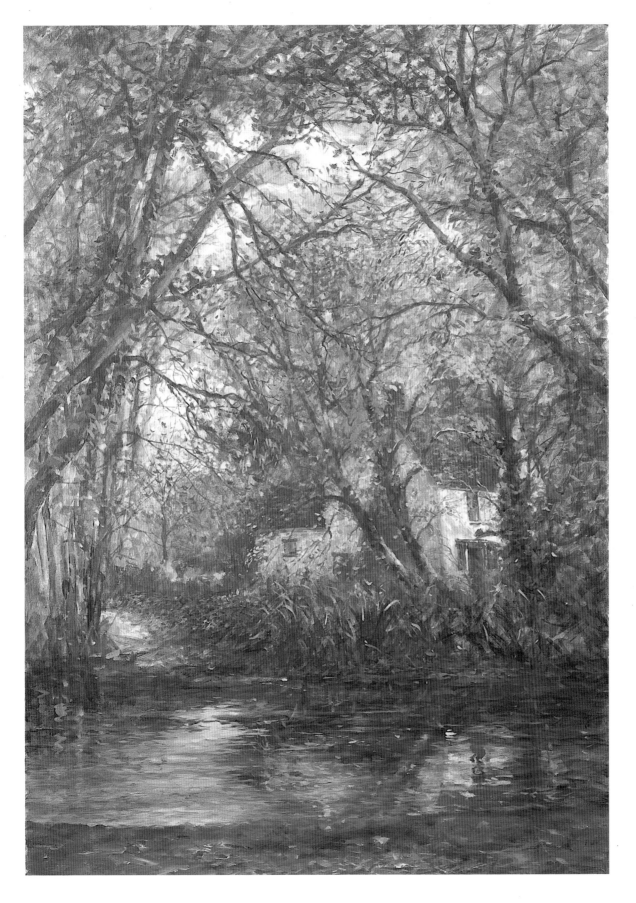

PROGRAMME 2
SKETCHING

'I am determined to finish a small picture on the spot for every large one I intend to paint. This I have always talked about, but have never yet done.'

John Constable

Although photographs can never take the place of sketching directly from nature, we are lucky to have the camera to help jog our memories when working indoors. Constable only had sketches to work from and, since some of his important studio paintings were worked on huge canvases, he needed plenty of information. During 1813 and 1814 he did hundreds of sketches in the Stour valley. Two of his tiny sketchbooks from this time, measuring around 8 x 11 cm (3¼ x 4½ in), can be seen in the Victoria and Albert Museum in London.

A TYPICAL SMALL SKETCH

The pencil sketch, below right, is a typical example of Constable's very small sketches and was used in the painting above it, 'The Stour Valley and Dedham Church', commissioned by Thomas Fitzhugh as a wedding present for his bride, Philadelphia Godfrey of Old Hall, East Bergholt. The view is from outside the grounds of Old Hall and there has been much speculation about why Constable included the labourers excavating the large dunghill for autumn manuring in the foreground!

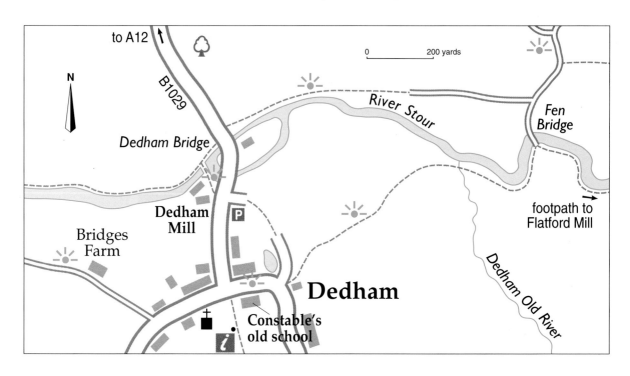

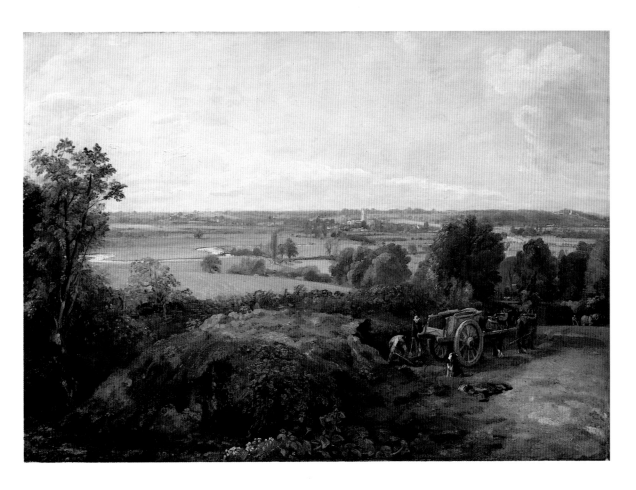

The Stour Valley and Dedham Church. *Constable 1814–15*
Oil on canvas 55.3 × 77.8 cm (21⅞ × 30⅝ in)
Warren Collection, Courtesy, Museum of Fine Arts, Boston

Detail from a page in his 1814 Sketchbook. *Constable*
Pencil 5½ × 8 cm (2⅛ × 3⅛ in)
By courtesy of the Board of Trustees of the Victoria & Albert Museum, London

Near the bottom of Fenbridge Lane there is a turning off over a wooden stile that leads across the meadows to Dedham. This is one of the paths that Constable could have taken to go to school. Of course, the stile is not the original, but it is just the type of subject that John Constable would have sketched while he wandered about gathering information for his paintings. I decided to sketch this in pencil, shown below.

PANORAMIC VIEWS

Not all Constable's sketches were details; some were studies of buildings, trees, small areas of landscape, panoramic views over Dedham Vale and the Stour Valley, etc.

What I find surprising is that some of the panoramic views were done in sketchbooks as tiny as 8 x 11 cm (3¼ x 4½). I would find that too restricting. I normally sketch A4-size, 20 x 28 cm (8 x 11 in).

Constable once said, 'When I sit down to make a sketch from nature, the first thing I try to do is to forget that I have ever seen a picture.'

I always tell students that, when you are sketching from nature, you should let the scene in front of you dictate how you work, regardless of the medium you are using. Don't let studio technique take over. When working at home, you might start by painting the sky but when sketching outside, you could well find yourself working the distant hills or a tree first because this seems the natural thing to do.

The pencil sketch, right, is from Constable's 1814 sketchbook. This was used for the composition of 'Boat-Building', which is shown below it, although the sketch shows a busier scene. The finished painting is of particular interest since it is the only one of Constable's paintings, as opposed to a sketch or study, that he is recorded as having said was worked completely outdoors.

Wooden Stile, Fenbridge Lane. *Alwyn Crawshaw*
2B pencil on cartridge paper, 12.5 × 17 cm (5 × 7 in)
After I have established the important elements in a sketch like this, I just let my pencil drift around and draw in details as I see them. Try not to work to a formula – always let your subject guide you.

1814 Sketchbook. *Constable*
Pencil 8 × 11 cm (3¼ × 4½ in)
By courtesy of the Board of Trustees of the Victoria & Albert Museum, London

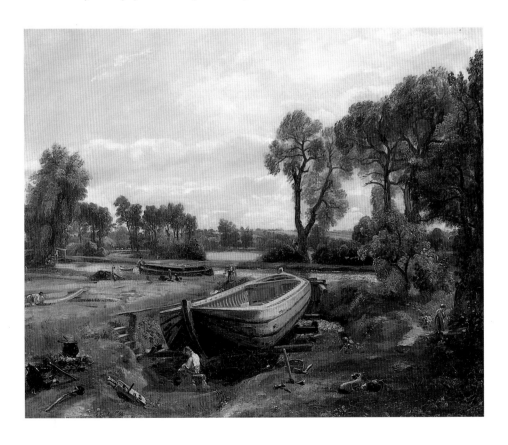

Boat-Building. *Constable 1814–15 Oil on canvas 50.8 × 61.9 cm (20 × 24⅜ in)*
By courtesy of the Trustees of the Victoria & Albert Museum, London

Another small sketch in the 1814 sketchbook was one of Flatford Mill with a prominent group of trees, shown opposite, and below it is the finished painting, 'Scene on a Navigable River (Flatford Mill)'.

AN INTERESTING DISCOVERY

The painting of Flatford Mill was done on a large canvas and, while researching for the series, I was very interested to find out how Constable established his perspective for this particular painting with another preparatory study, which was acquired by the Tate Gallery in London in 1988.

For this was no ordinary drawing. It was a pencil tracing of an image made with a brush, and possibly printing ink, on a sheet of glass which would have been held on an easel in front of the scene.

One of my stock sayings over the years has been how I felt sure that, had the camera been invented in Constable's day, he would certainly have used one to help him with his paintings – I am convinced of this now.

Constable's tracing would have been made by placing a piece of paper over the image on the glass. Because this was still wet, it produced an accidental offprint on the back of the paper. Squared for transfer to the canvas, the drawing includes the two barges but none of the figures seen in the painting.

MORE USES FOR SKETCHES

Sketches can also be used to record the composition of scenes for future paintings. The one below was done for this reason. It also shows how quickly a small sketch can be worked and took me about 8 minutes to do.

The object of the exercise isn't to see how fast you can work but to show how much information you could gather on a day out sketching – maybe as many as 6–10 sketches. I would normally work on larger, A4-size paper, 20 x 28 cm (8 x 11 in) and perhaps also take photographs if it were a complicated scene. I could then work a bigger, more detailed painting from the sketch, and my memory, back in the studio.

BELOW: **Dedham Lock and Mill from below the road bridge.**
Alwyn Crawshaw
2B pencil on cartridge paper, 10 × 15 cm (4 × 6 in)
We all have our favourite paper size for working on – I usually prefer to work larger than this. Of course, size really isn't important as long as you record enough information for your needs. Even when doing small sketches, you should still observe your subject carefully – this is a useful learning process for the artist.

1814 Sketchbook. *Constable Pencil*
11 × 8 cm (4½ × 3¼ in)
By courtesy of the Trustees of the Victoria & Albert Museum, London

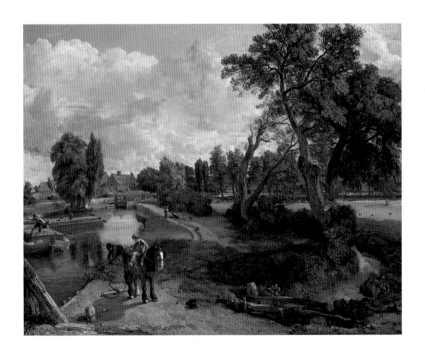

Scene on a Navigable River (Flatford Mill). *Constable 1816–17*
Oil on canvas 101.7 × 127 cm (40 × 50 in)
Tate Gallery, London

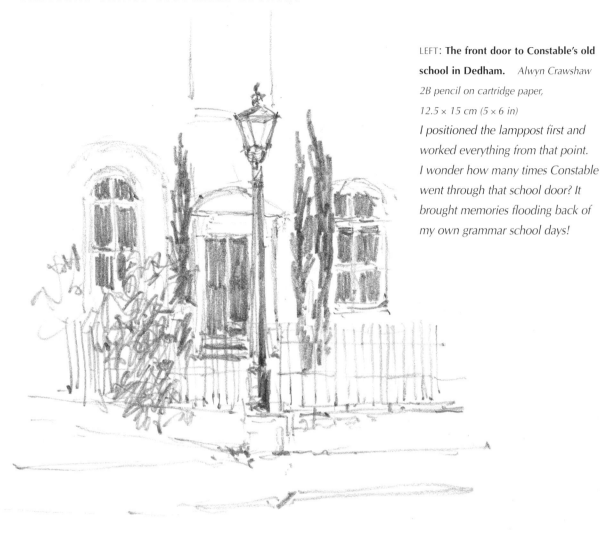

LEFT: **The front door to Constable's old school in Dedham.** *Alwyn Crawshaw 2B pencil on cartridge paper, 12.5 × 15 cm (5 × 6 in)*

I positioned the lamppost first and worked everything from that point. I wonder how many times Constable went through that school door? It brought memories flooding back of my own grammar school days!

Not all sketching is purely for gathering information to work from later. A sketch can be done for the sheer enjoyment of capturing a subject or recording an event. Of course, depending on the subject, it could still be used for information. You might even decide to frame it and hang it with pride as a creative work of art in its own right, or simply keep it as a 'memory lane' sketch.

CONTINUING MY JOURNEY

After walking down Fenbridge Lane, where I sketched the stile on page 28, and continuing across the meadows to Dedham Lock, where I

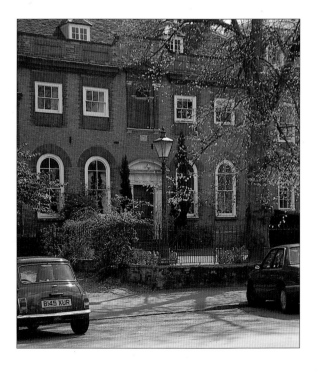

RIGHT: *Now a private house, this building used to be Dedham Grammar School.*

did the small pencil sketch on page 30, I then wandered around Dedham village looking for things to sketch and came across the building that was once Dedham Grammar School. It is now a private house but I couldn't resist doing the pencil sketch of it, left, just for the joy of sketching Constable's old school.

CONSTABLE'S SCHOOLDAYS

I decided that the lovely old lamppost outside should be the point of interest, with just a suggestion of the school behind it. I really enjoyed doing this sketch and tried to imagine the happy moments and anxious times that the young John Constable must have had as a schoolboy in that building.

The headmaster of Dedham school in Constable's day was the Revd Dr Grimwood – what a name for a headmaster! However, he quickly recognized Constable's potential in art and encouraged him, so I think we have a great deal to thank Dr Grimwood for.

Later, walking along the river, I did the pencil sketch of two trees, below. This scene inspired me because the trees were silhouetted, with the sun behind them.

As I said before, sometimes a subject catches your eye and you just have to sketch it for the pure pleasure of the moment. This was one of those wonderful times, and I am sure John Constable must have often felt the same way as he wandered about the Suffolk countryside.

When this happens, it really doesn't matter how the finished sketch turns out. The sheer joy of doing it is reward enough.

BELOW: **River Stour between Dedham and Flatford.**
Alwyn Crawshaw
2B pencil on cartridge paper, 20 × 28 cm (8 × 11 in)
When doing this sketch, I let my pencil work over the paper in quick, broad strokes. I particularly wanted to capture the interesting shape created between the two trees. I was lucky – a rowing boat appeared and so I quickly put it in to give scale.

Of course, sketches don't have to be done in pencil. John Constable used oil and occasionally watercolour to do what I would call 'atmosphere sketches'. His oil sketch, 'Stoke-by-Nayland', shown opposite, captures the atmosphere of a summer's day perfectly. 'A Country Lane', shown below it, was done approximately twenty years later. Scholars think it is of the same location, but this time Constable has captured a very different atmosphere, using a different medium.

CAPTURING THE MOOD

Whether you decide to use pencil, watercolour or oil for a sketch will depend on the day, your subject and the mood you're trying to capture. Pencil is useful for sketching almost anything

and is universally used for sketching, so I always carry a 2B pencil and a sketchpad wherever I go.

Sketching is a good way of practising and learning and, therefore, progressing with your painting – and this applies to professional artists as well as students. In John Constable's own words: 'There has never been a boy painter, nor can there be. The art requires a long apprenticeship, being *mechanical*, as well as intellectual.'

BELOW: **Dedham Church, late evening.** *Alwyn Crawshaw*
Oil on canvas, 25 × 30 cm (10 × 12 in)
I felt that this subject was a perfect one to sketch in oil. The sun was setting and the whole scene was almost in silhouette.

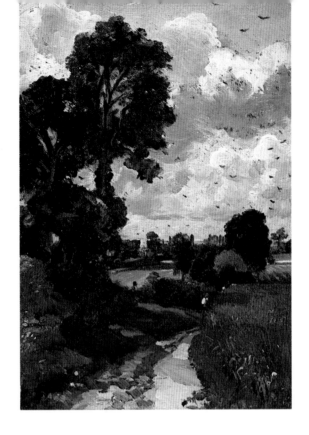

Stoke-by-Nayland. *Constable 1816*
Oil on paper laid on canvas 26.7 × 18.4 cm (10½ × 7¼ in)
Private collection of Mr and Mrs David Thomson

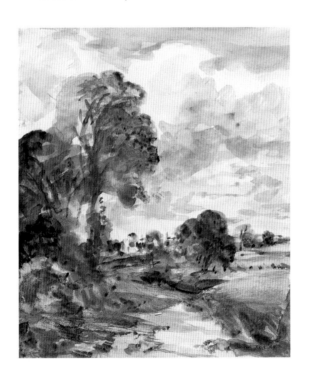

A Country Lane. *Constable c.1836*
Pencil and watercolour on wove paper 21.3 × 18.3 cm (8⅜ × 7³⁄₁₆ in)
By courtesy of the Board of Trustees of the Victoria & Albert Museum, London

The barns on Bridges Farm.

Alwyn Crawshaw

Watercolour on cartridge paper,

28 × 43 cm (11 × 17 in)

I was shown this interesting view of Dedham Church by Terry Jeffrey, a local artist. The church tower seems to pop up everywhere (see page 38). I am not aware of a painting of this particular view by John Constable. However, the farm existed in his day and I am sure he walked in these fields – unless the farmer wasn't as friendly as the present owner!

When we arrived for filming, it was mid-afternoon on a fresh, windy day in May. The sun was casting long shadows and I felt that the scene would work best in watercolour.

My inspiration for the sketch was the way the sunlit areas contrasted with the strong dark shadows.

I used bright colours and dark shadows (tone) to capture the feeling of the sunny, blustery spring day. The movement made by my brush strokes in the foreground shadow helped to create the impression of the long grass blowing in the wind.

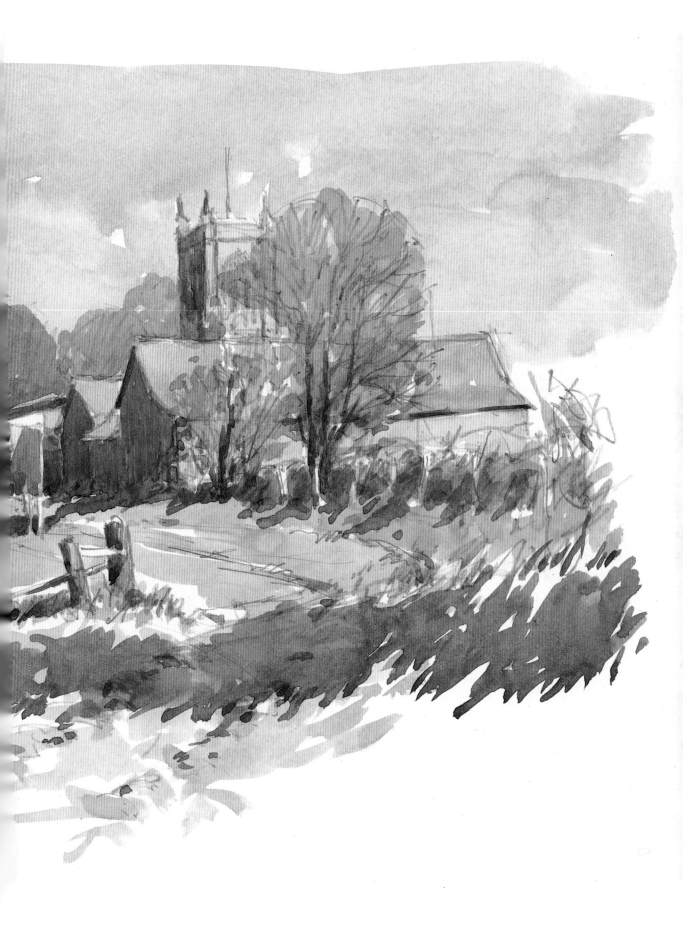

PROGRAMME 3
CHURCHES

Churches feature frequently in Constable's landscapes and the one that appears the most is Dedham Church. This is hardly surprising since it stands over 40 metres (130 feet) tall and is a prominent landmark for miles around the relatively flat countryside. The biggest church in the parish, it was completed in 1519. One of the bells, which was cast in 1410, over a century earlier, still rings out loud and clear today.

INDUSTRIAL MEMENTOS

The current vicar, Revd John Druce, told me that the tower is not only very tall but also exceptionally wide. Most of the churches in this area were built during medieval times when the successful local weaving trade made the area extremely prosperous. Dedham had some rich and generous benefactors at that time, hence the very large church tower. Constable described this church as having 'mementos of an industrial race'.

Before we started filming, I walked down the river and sketched the church in pencil through the trees from the meadow, right.

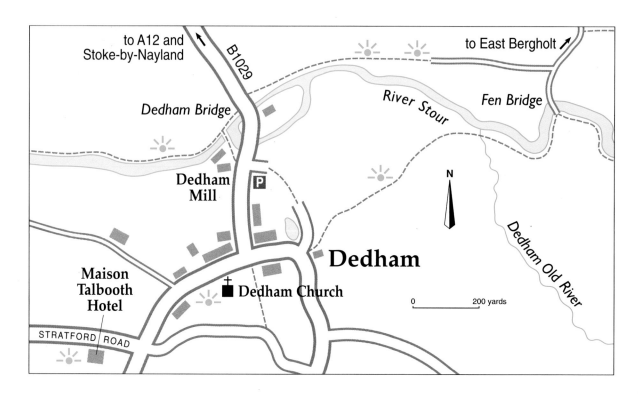

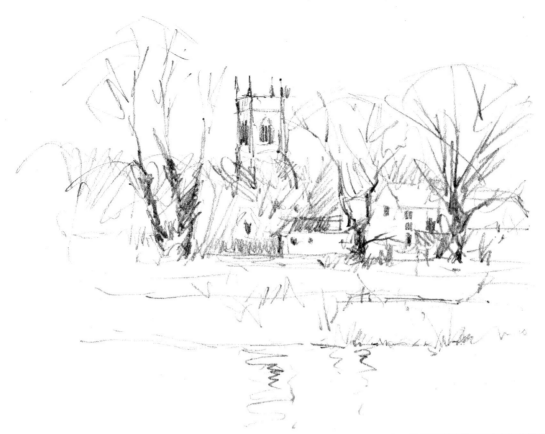

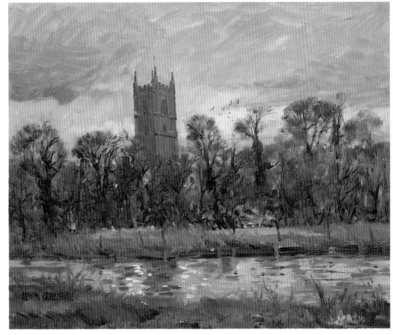

ABOVE: **Dedham Church from the meadow.** *Alwyn Crawshaw*
2B pencil on cartridge paper,
20 × 30 cm (8 × 12 in)
This sketch was done very quickly and freely, but I took time to observe the scene and familiarize myself with it before starting.

Incidentally, it has been said that an artist does the sketch for love, the picture for an exhibition.

I think this was more the case in Constable's time when sketches were seldom done for public view and only 'finished paintings' were shown at exhibitions. Nowadays, sketches are often shown alongside finished paintings in exhibitions.

ABOVE: **Dedham Church from above the Mill.** *Alwyn Crawshaw*
Oil on primed hardboard, 25 × 30 cm (10 × 12 in)
I painted this oil of Dedham Church from a pencil sketch which I did upstream from the one above.

John Constable did the pencil sketch of Dedham Church, below, from the front entrance, and this shows the tower and the vicarage. It was decided that I would do a pencil sketch from approximately the same position for television.

UNCHANGED BY TIME

Like Willy Lott's Cottage, the church hasn't changed since Constable drew it and I must have been sitting, if not in the exact place, only a short distance away from where he sat all that time ago.

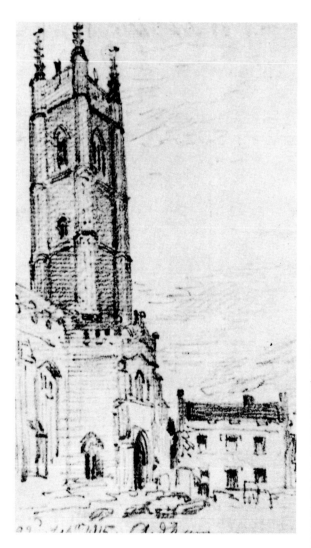

Pencil sketch of Dedham Church. *Constable 1815 Reproduced by courtesy of Messrs Sotheby Park Bernet & Co, London W1 and Dedham PCC*

I must admit I was a little concerned because David, the producer, had asked me to do a 'quick' sketch, because of the time allotted to this section in the programme. The problem was that from my sketching position I was close enough to the church to see every mark in the stonework, and the tower almost blotted out the sky! When I can see an object so clearly, I find it difficult not to add detail.

I did the sketch in my own time and it took about 25 minutes.

ARTISTIC LICENCE

When I compared my finished sketch to Constable's, it was good to see the Master also used artistic licence in some of his work. He has made the tower much narrower than the real one. Perhaps I could have made mine a little taller to give the illusion of height, but I think I have got the feeling of strength through the width of the tower.

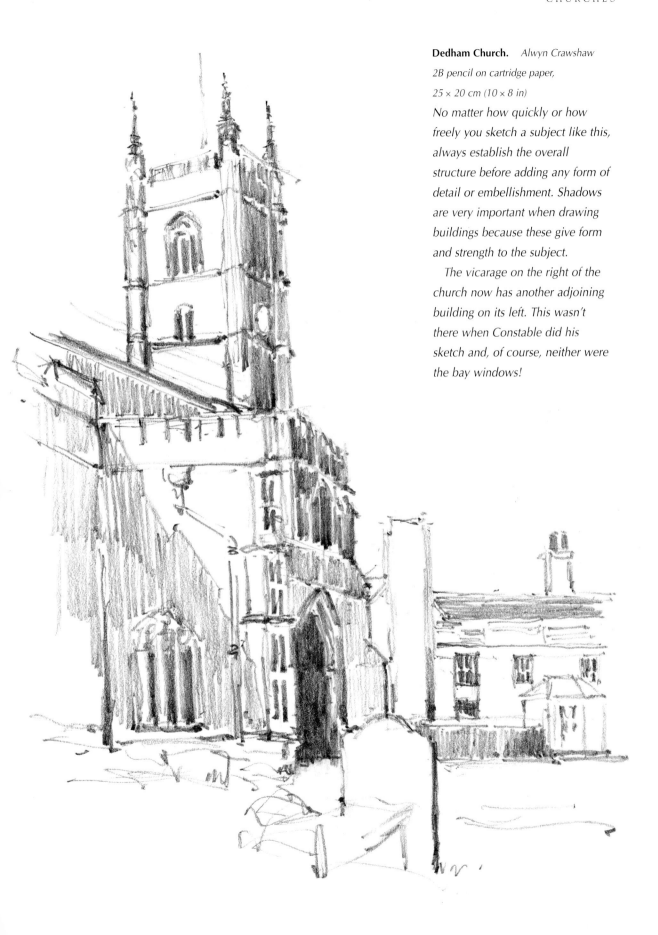

Dedham Church. *Alwyn Crawshaw*
2B pencil on cartridge paper,
25 × 20 cm (10 × 8 in)
No matter how quickly or how freely you sketch a subject like this, always establish the overall structure before adding any form of detail or embellishment. Shadows are very important when drawing buildings because these give form and strength to the subject.

The vicarage on the right of the church now has another adjoining building on its left. This wasn't there when Constable did his sketch and, of course, neither were the bay windows!

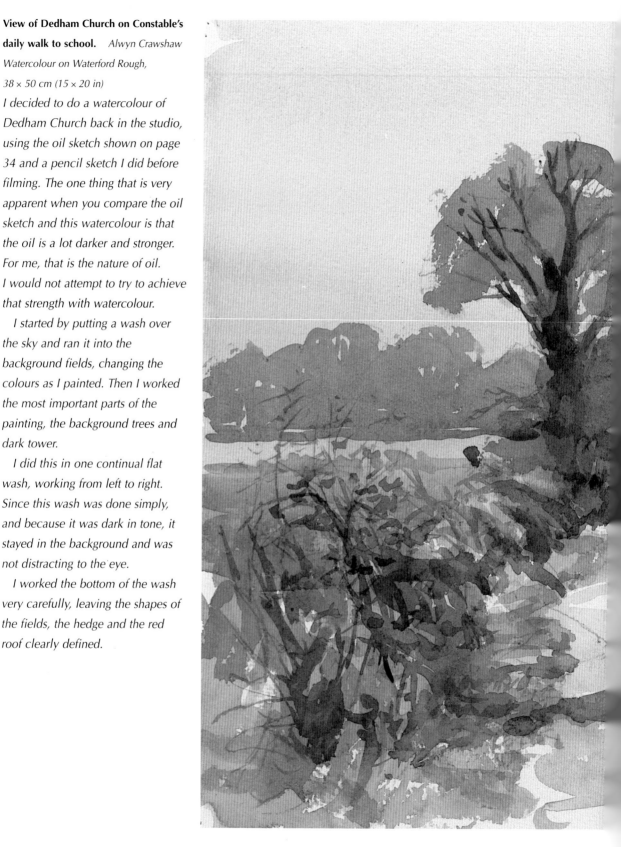

View of Dedham Church on Constable's daily walk to school. *Alwyn Crawshaw Watercolour on Waterford Rough, 38 × 50 cm (15 × 20 in)*

I decided to do a watercolour of Dedham Church back in the studio, using the oil sketch shown on page 34 and a pencil sketch I did before filming. The one thing that is very apparent when you compare the oil sketch and this watercolour is that the oil is a lot darker and stronger. For me, that is the nature of oil. I would not attempt to try to achieve that strength with watercolour.

I started by putting a wash over the sky and ran it into the background fields, changing the colours as I painted. Then I worked the most important parts of the painting, the background trees and dark tower.

I did this in one continual flat wash, working from left to right. Since this wash was done simply, and because it was dark in tone, it stayed in the background and was not distracting to the eye.

I worked the bottom of the wash very carefully, leaving the shapes of the fields, the hedge and the red roof clearly defined.

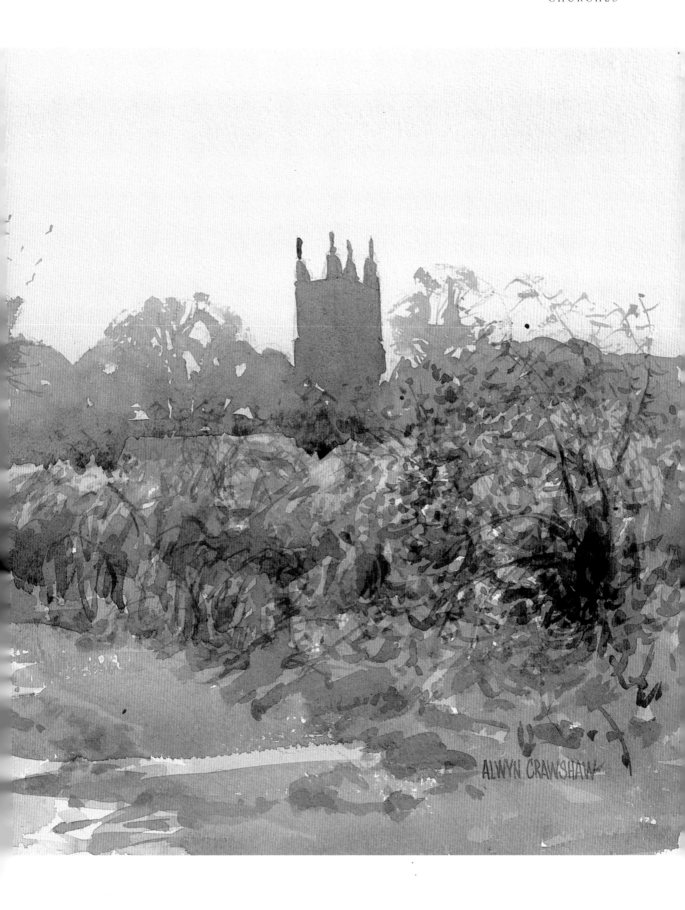

ALWYN CRAWSHAW

The church had quite an influence on Constable's life. In 1809 he fell in love with Maria Bicknell (see her portrait, opposite), whose grandfather was the rector of East Bergholt, but Maria's family weren't happy with the idea of an artist marrying their daughter – it was not felt to be suitable employment.

A LONG COURTSHIP

In an attempt to win over her grandfather, Constable painted a watercolour of East Bergholt Church and gave it to him. Unfortunately, this attempt to win favour didn't work and the Reverend's opposition to their relationship delayed their wedding for another five years after the painting had been given.

During their long, frustrating courtship, the unhappy couple remained constant to each other. They were often parted and sometimes forbidden even to write. After a seven-year engagement, they were finally married at St Martin-in-the-Fields in London on 2 October 1816.

SOLITUDE

Poor John and Maria! I can't help wondering whether those long years of waiting must have given Constable some unhappy and difficult times with his painting. In one letter to Maria, he wrote that he would endeavour to follow her advice 'in this gloom of solitude'. Although

I can sometimes 'lose' myself and forget my problems when painting a landscape, I do find I paint my best when my home life is happy and comfortable.

East Bergholt Church doesn't feature much in Constable's landscapes, probably because it has no tower to speak of, and couldn't be seen from a distance. Or was it also because of its unfortunate association in John Constable's mind with Maria's grandfather? I can just imagine how he would have felt if he had seen East Bergholt's church tower as often as he saw the tower of Dedham Church when painting a landscape!

CLOSER VIEWS

However, John Constable did sketch and draw East Bergholt Church from close up on quite a few occasions. On the opposite page is a drawing that he did of his parents' tomb there. The farmer, Willy Lott, is also buried in the churchyard, but John Constable is buried beside Maria in Hampstead Parish Churchyard.

East Bergholt Church is quite attractive but I decided against sketching it, not because of Constable's unhappy connection with it, but simply because it is too 'architectural' for my type of painting. I decided to continue on my travels to Stoke-by-Nayland, a few miles away.

BELOW: *Filming in East Bergholt churchyard.*

44

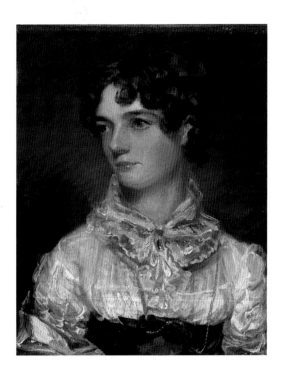

Portrait of Maria Bicknell. *Constable 1816*
Oil on canvas 30.1 × 25.1 cm (12 × 10 in)
Tate Gallery, London

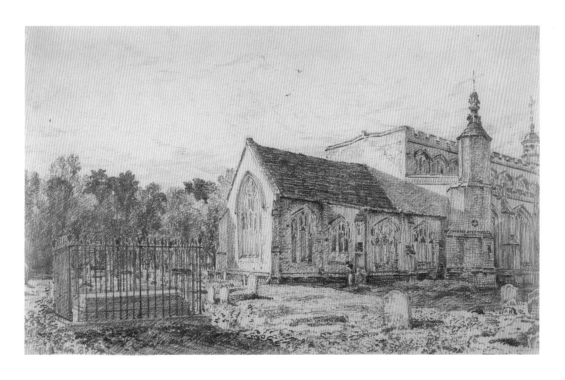

East Bergholt Church, with the Tomb of the Artist's Parents. *Constable 1819*
Pencil on trimmed wove paper 19.6 × 32 cm (7¾ × 12⅛ in)
Private Collection of Mr and Mrs David Thomson

St Mary's Church in Stoke-by-Nayland (see the map on page 9) is approximately 7 miles from Dedham. Situated on top of a hill, it has a commanding view over the surrounding countryside. At the top of the opposite page is a large oil sketch, with the church in the background, that John Constable did. However, he never painted a finished picture from it.

THE VIEW FROM THE TOP

The views from the tall tower of St Mary's Church are magnificent. I know because I went up it during filming with the crew.

The climb up the winding stone staircase is quite an experience. About halfway up, the stairs get so narrow that your shoulders touch the walls on either side and it really feels as though the walls are leaning in on you! It is a bit like climbing up a very narrow funnel. At one point on the journey, we were plunged into total darkness for about fifteen steps. Luckily, Eddie, our soundman, had a torch handy and, once it was switched on, we could at least see our feet!

Eventually, we crawled out of the old wooden door at the top, covered from head to foot in thick stone dust! In the end it was worth it – the views from there were wonderful.

I then did a pencil sketch of St Mary's Church, shown below. As you can see from the photograph on the next page, I was positioned close to the church to do this, working in the road.

A LESS DETAILED SKETCH

I speeded up my drawing, putting in a lot less detail than I had for my sketch of Dedham Church on page 41, and completing it in 15 minutes. I was very happy with the sketch. My journey then took me back to Dedham.

BELOW: **St Mary's Church, Stoke-by-Nayland.**
Alwyn Crawshaw
2B pencil on cartridge paper, 20 × 28 cm (8 × 11 in)
The tower seemed much taller than it looks in my drawing, when I had climbed to the top of it!

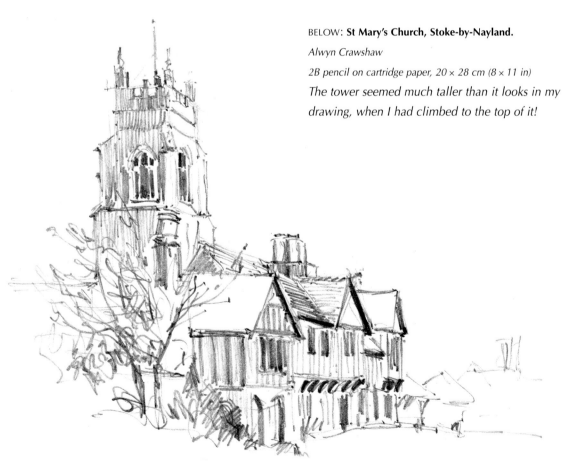

Stoke-by-Nayland. *Constable 1836*

Oil on canvas 126 × 168.8 cm (49½ × 66⅛ in)

Mr and Mrs W. W. Kimball Collection. Photograph © 1996, The Art Institute of Chicago. All Rights Reserved

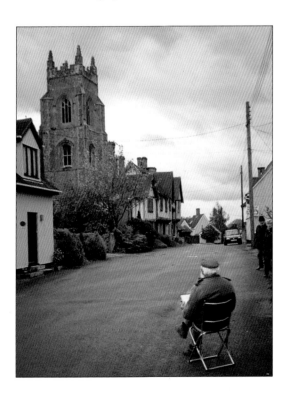

Sketching St Mary's Church in Stoke-by-Nayland.

LEFT: **Dedham Church from the meadows below Dedham Mill.**

Alwyn Crawshaw

Oil on primed hardboard,

25 × 30 cm (10 × 12 in)

Because the two trees in the foreground were partly covering the church tower, I used my artistic licence for this painting and moved them to the left. I could have changed my painting position but I wanted to be near the hedgerow because of an impending hailstorm!

As I wandered around, looking in the direction of Dedham, the church tower could be seen on the skyline from various viewpoints. It makes an excellent point of interest for the artist, and it is easy to see why it appeared in so many of Constable's paintings. However, he did use his artistic licence, on occasions, by moving the church and, in his painting, 'Dedham Vale', right, the church tower has been exaggerated in height again, to give it more prominence.

MAKING ADJUSTMENTS

Of course, when an artist paints a scene back in the studio, there is time to rethink its various elements and the overall composition of the picture. During this process, various elements can be adjusted for the benefit of the painting. However, a word of warning for the inexperienced student – don't be tempted to use your artistic licence and change nature too much. Experience will guide you as you progress but, when in doubt, paint what you see. Constable once remarked about the composition of a picture that: 'Its parts were all so necessary to it as a whole, that it resembled a sum in arithmetic; take away or add the smallest item, and it must be wrong.'

'BRIGHT AND SILVERY DAYS'

I painted the oil sketch of Dedham Church, above, from the riverbank, but I had to stop halfway through it because of a hailstorm. Once the weather had cleared, I was able to complete the sketch. Constable must have encountered painting days like this and, indeed, wrote of: 'One of those bright and silvery days in the spring, when at noon large garish clouds surcharged with hail or sleet sweep with their broad shadows the fields, woods and hills; and by their depths enhance the value of the vivid greens and yellows so peculiar to the season.'

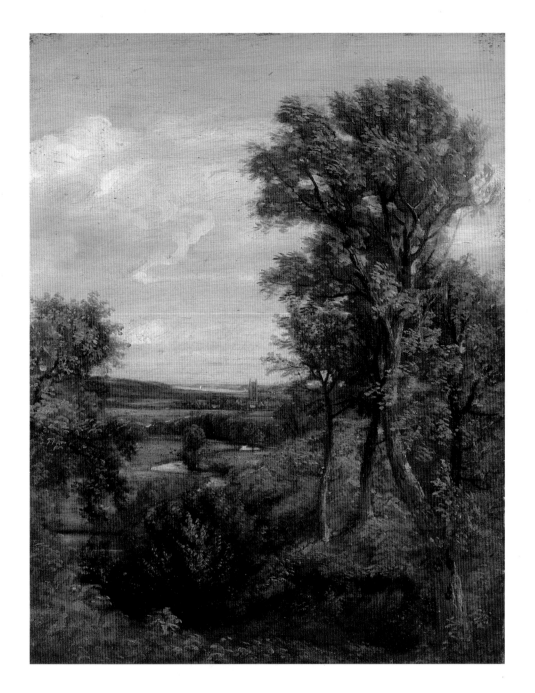

Dedham Vale. *Constable 1802 Oil on canvas 43.5 × 34.4 cm (17⅛ × 13½ in)*
By courtesy of the Board of Trustees of the Victoria & Albert Museum, London

Dedham Church from the Maison Talbooth hotel. *Alwyn Crawshaw*
Oil on primed hardboard,
30 × 40 cm (12 × 16 in)

I found another great viewpoint for Dedham Church from the grounds of the Maison Talbooth, the hotel where we were staying while making the television series.

Three attempts were made to film me painting this view but the weather was against us and, running out of time, we had to do it on the fourth attempt, although it was still overcast and dull. However, I must say that the soft and subtle colours in the scene were very inspiring.

It was important to keep the whole painting in the same low key, so I picked out the shapes of some trees but let most of them merge into one another. When trying to capture this type of atmosphere, you must avoid putting too much detail or strong colour into specific areas of the painting, or you will lose the overall effect of 'misty softness'.

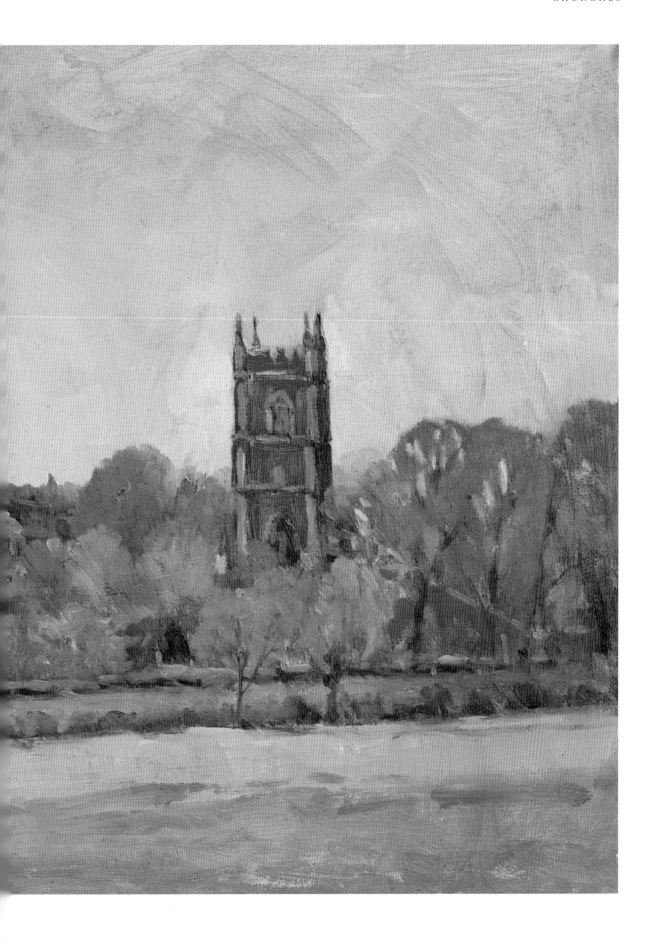

Dedham Church from the Maison Talbooth hotel, early morning.

Alwyn Crawshaw Oil on primed canvas, 60 × 91 cm (24 × 36 in)

I painted this picture back in the studio from a pencil sketch and a photograph that I had taken in the autumn, before we filmed the television series.

It is interesting to compare this studio painting with the one done on the spot (see the previous page). This one is bigger. It is much more convenient to work small outdoors. However, working larger in the studio allowed me to rethink things and put in more detail where I felt that it was necessary, particularly since I was working in controlled conditions.

It was early morning when I did the preliminary sketch for this painting. The air was crisp and clean and the sun was very low and hitting the side of the tower and the red rooftops with an exaggerated light. So, one obvious difference from the previous painting, which was done on a dull, overcast day, was that the colours here had to be strong and bright, to give the illusion of strong, low sunlight.

Four close-up details from this painting are shown overleaf.

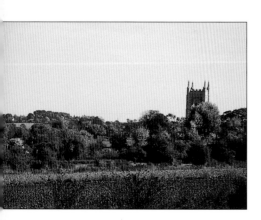

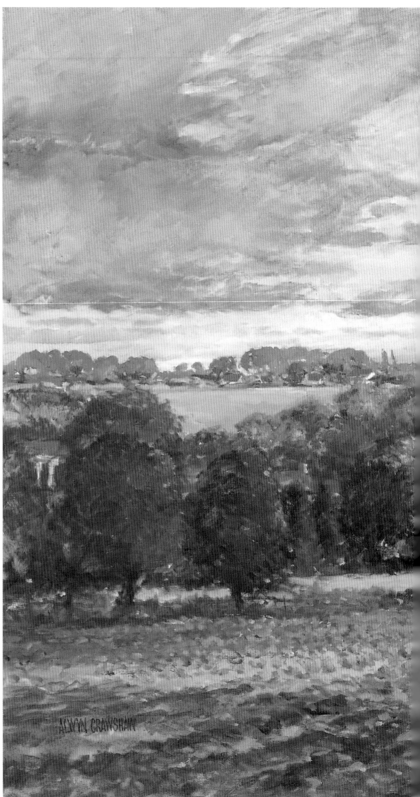

ALWYN CRAWSHAW

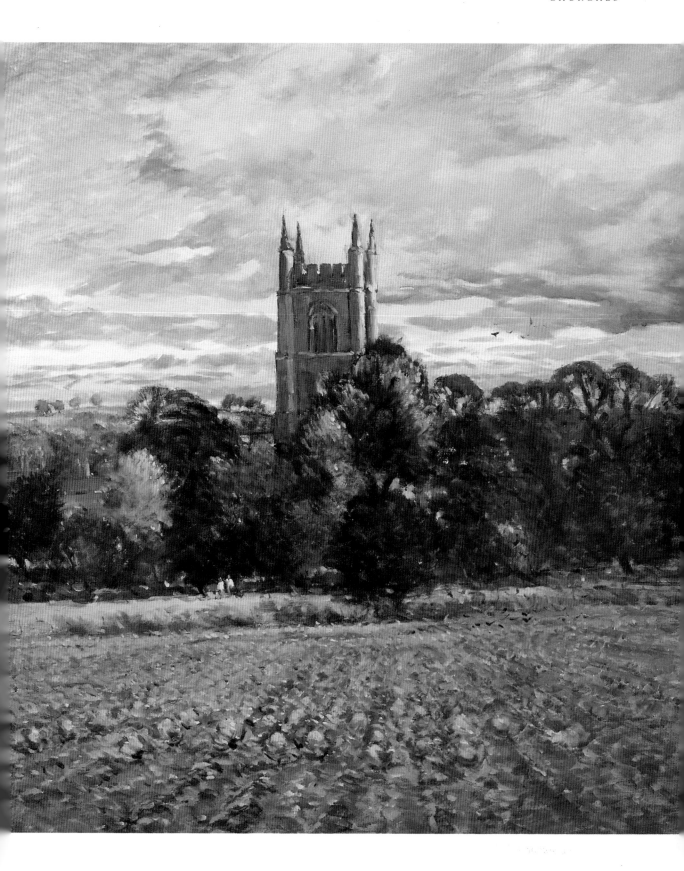

CLOSE–UP DETAILS

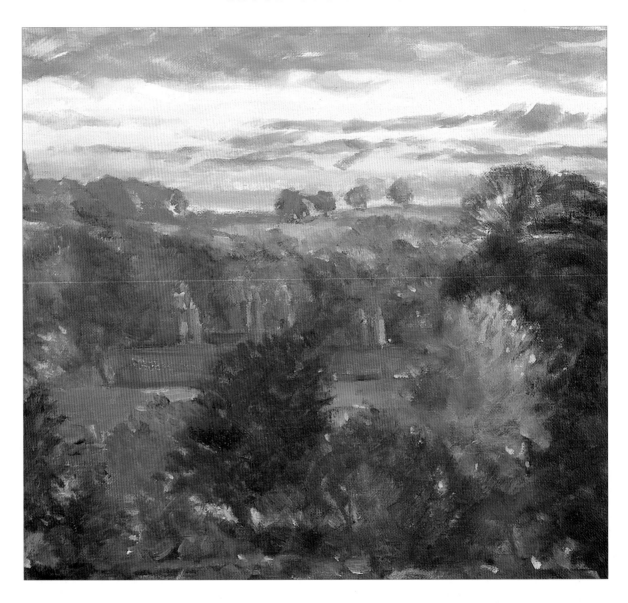

ABOVE: *I didn't try to put any detail into the house. The most important consideration was the colour of the roofs, and this was achieved with Cadmium Red, a little Cadmium Yellow and a little Titanium White. Notice how the green tree has caught the sunlight – this is exaggerated by the very dark trees behind it. The sky colours are soft and delicate and become warmer as they get closer to the sun on the right of the picture.*

RIGHT: *The detail shows how simply the figures were painted in. Notice how I placed them in front of the very dark trees, to show them off to advantage (light against dark). Although they are very small in the whole composition, the eye can* · *easily see them.*

RIGHT: *Because the sun is on the right of the scene, the sky is much cooler on the left-hand side of the painting, and this helps to make that part of the sky recede. Notice how the rooftops of these houses aren't as strong in colour as the ones in the foreground. The trees behind the houses are a very strong bluey-mauve colour and, because they are silhouetted against the sky, an illusion of space is created behind them.*

RIGHT: *I decided to paint sunlight on the field. Originally, it was going to be in shadow, but I felt that this part of the painting needed some area of interest. I put the sunlight on the left of the field – if it had been on the right, it would have distracted the eye from the church tower. The sunlit area has been worked in cool colours so that it doesn't compete with the bright green of the field or the bright red of the houses.*

PROGRAMME 4
TREES, MEADOWS AND SKIES

'This fine weather almost makes me melancholy; it recalls so forcibly every scene we have visited and drawn together. I even love every stile and stump, and every lane in the village, so deeply-rooted are early impressions.'

John Constable

∼

The meadows between Dedham and Flatford Mill are full of inspiration for the landscape artist. Nowadays, a public footpath runs along the riverbank, and there are plenty of spots to sit and enjoy the view. You can park your car in either place, and the walk between them along the river can be done easily in a morning or afternoon. Alternatively, visitors can hire a rowing boat and take a gentle trip along the river!

Modern artists can pile their painting equipment into a car and drive to distant painting spots but, of course, this wasn't the case in John Constable's day. It was important then to have subjects to paint close to home or a great deal of painting time could be wasted. In one letter, Constable wrote: 'The loss of four days on the road is serious, and I am now in the midst of a great struggle, and time is my estate.'

Most of Constable's Suffolk pictures portray scenes within walking distance of his home in East Bergholt. Each spring and summer, he could be found sketching the countryside there, while his extensive knowledge of the area served him well when he returned to his studio in London with memories and sketches of his beloved Suffolk.

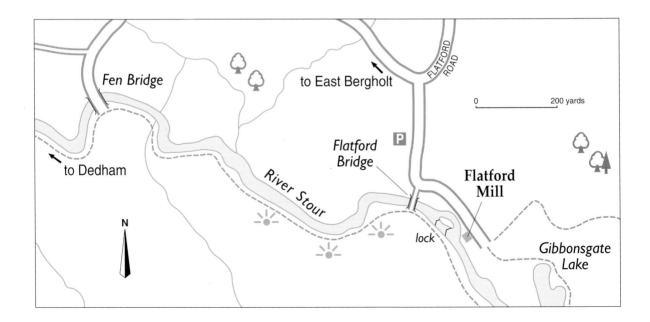

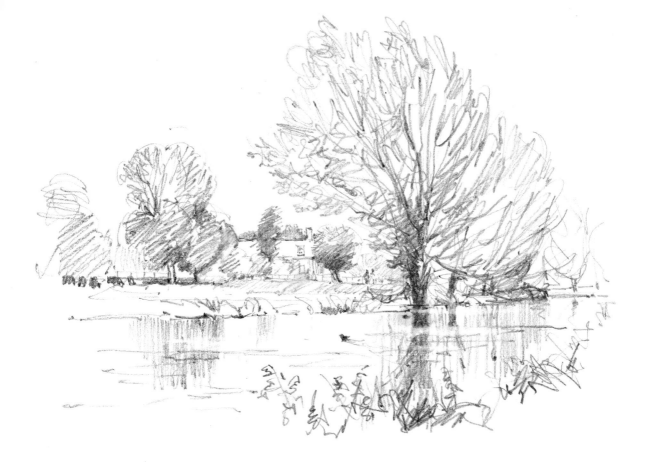

ABOVE: **Flatford Mill from the meadows.**

Alwyn Crawshaw

2B pencil on cartridge paper,

20 × 28 cm (8 × 11 in)

I did this pencil sketch on one of my walks on the riverbank, before filming. I am sure that one day I shall use it as a starting point for a large studio painting. Notice how I suggested two figures to the left of the tree. They walked into view while I was sketching and I put them in because they help to show distance and scale in that part of the scene – important information if I use the sketch to paint from back in the studio.

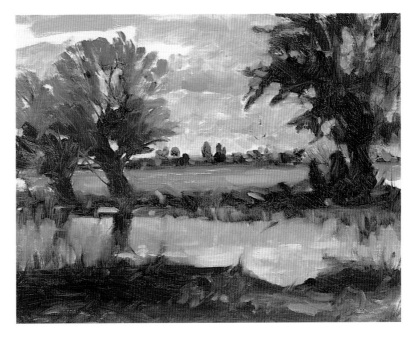

ABOVE: **Willow trees near Flatford.**

Alwyn Crawshaw

Oil on sketching paper,

25 × 30 cm (10 × 12 in)

The most important aspect of this sketch was capturing the bright sky behind the silhouetted willows on the left, and its reflection in the river. I used a No. 4 flat bristle brush for all the work, except between the branches of the willow trees, where I used a small No. 4 round brush.

Between Dedham and Flatford is the site of one of John Constable's most famous paintings of the Stour, 'The Leaping Horse', shown right.

ABOVE: *I couldn't believe I was standing on the actual spot where the horse jumped over the barrier in John Constable's painting!*

BACK IN TIME...

As I stood on the bridge that overlooks the stream, which now has a modern fence and gate over it, my imagination took hold of me again. Soon I was daydreaming, and back in Constable's time. Unfortunately, the sound of a jet aeroplane flying overhead abruptly returned me to reality, and I had to content myself with looking at a reproduction of the painting I had brought with me, and comparing it with the scene as it now is.

Constable painted a full-size sketch first, which is also shown on the opposite page. Having seen both paintings in the original, I am still not sure which one I prefer best. Although I love the freedom and movement generated in the sketch, I also admire the strength and detail of his finished painting.

BARGE-HORSES

In both pictures, the horse is jumping over a stile. In those days, horses were used to tow barges along rivers and canals, but the towpaths of the Stour were interrupted by wooden barriers high enough to prevent cattle from straying from one field to another. Since these barriers had no gates, the barge-horses were trained to leap over them. It was not an easy manoeuvre for the horse or the rider, and I can't imagine why the barriers weren't gated, so that horses could simply walk through them. However, having the horse leaping certainly helped Constable's composition!

THE MOVING WILLOW

An interesting point about the scene is that the horse is jumping from Essex into Suffolk, the stream being the county boundary. In the finished painting, you can see that Constable moved the pollarded willow from in front of the horse to a position behind it – in fact, from Suffolk to Essex!

Constable found 'The Leaping Horse' a very difficult painting to do. Writing to his friend John Fisher just after he had sent the painting to the Academy in 1825, he said: 'No one picture ever departed from my easil with more anxiety on my part with it.' Although it was critically acclaimed, the painting wasn't sold until after his death in 1837.

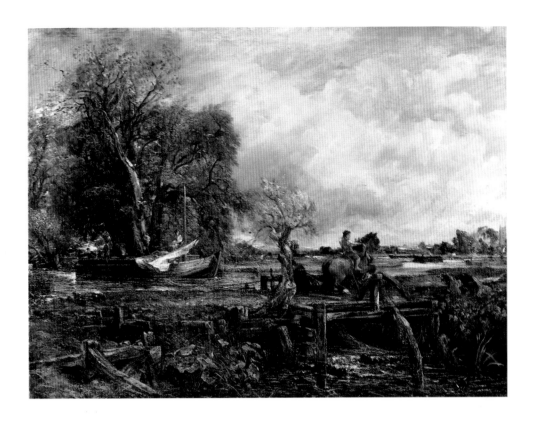

The Leaping Horse. *Constable 1825 Oil on canvas 142.2 × 187.3 cm (56 × 73¾ in)*
By courtesy of the Royal Academy of Arts, London

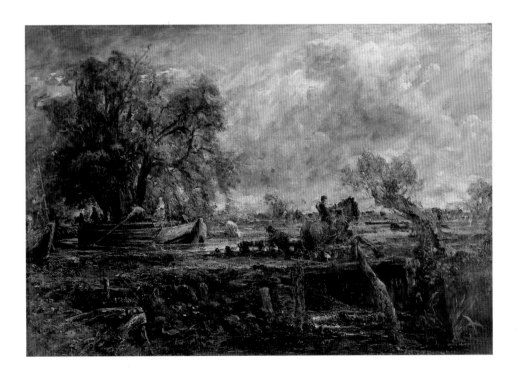

Sketch for 'The Leaping Horse'. *Constable 1824–5 Oil on canvas 129.4 × 188 cm (51 × 74 in)*
By courtesy of the Board of Trustees of the Victoria & Albert Museum, London

Continuing along the riverbank towards Flatford, I saw plenty of pollarded willows. One, in particular, took my artistic fancy, and I decided to do a pencil sketch of it, shown below. If you wanted to make a study of this type of tree, your subject is in abundance here in these meadows.

MAKING CHANGES

It is interesting to note that when Constable painted 'Scene on a Navigable River (Flatford Mill)', see pages 31 and 77, he wasn't happy with the trees on the right-hand side of the painting, so he went out and made another study of trees, shown at the top of the next page. He then repainted the tops of the trees in his original picture, and this is what we see today.

Constable's favourite tree was the ash. Also shown on the next page is a very carefully-drawn study of an ash tree that he did in 1835.

BELOW: **A pollarded willow near Flatford.** *Alwyn Crawshaw*
2B pencil on cartridge paper, 20 × 28 cm (8 × 11 in)
This was the willow that I decided to sketch. In the photograph of the tree, above, you can see that the tower of Dedham Church has managed to get into the picture, to the right-hand side of the tree!

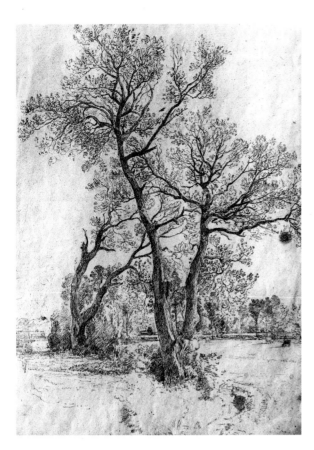

Trees on the Towpath at Flatford. *Constable 1817*
Pencil on deckle-edged wove paper
55 × 38.7 cm (21⅝ × 15¼ in)
By courtesy of the Board of Trustees of the
Victoria & Albert Museum, London

An Ash Tree. *Constable 1835*
Pencil and watercolour
99 × 68 cm (39 × 26¾ in)
By courtesy of the Board of Trustees of the
Victoria & Albert Museum, London

I found a very interesting group of ash trees to sketch not far from Flatford Mill. They weren't in full leaf yet, and so I could see the shapes of the branches easily.

I really enjoyed doing this drawing, sitting on the side of the river, close to the mill. From where I was, I could see Flatford Bridge, with the mill behind it. The smell of spring was in the air, a breeze was blowing across the meadows, and the sunlight was dancing on the river.

A WATCHFUL EYE!

As I sketched, an inquisitive duck and drake waddled up and stood at my feet, watching me work, while the crew carried on filming!

As I painted, some of John Constable words echoed in my head. He once said: 'The world is wide; no two days are alike, not even two hours; neither were there ever two leaves of a tree alike since the creation of the world.'

I believe this is the reason why the landscape artist will always be inspired and find something new in nature to paint.

ABOVE: *Sketching the trees for television.*

LEFT: **Ash trees on the riverbank near Flatford Mill.**
Alwyn Crawshaw 2B pencil on cartridge paper,
28 × 43 cm (11 × 17 in)
The two main things on which to concentrate when sketching a group of trees are the positioning of the main trunks and the overall shape (mass) of the main branches. Once these factors have been established, either by simple pencil lines on the drawing, or in your mind, you should find the smaller branches relatively easy to position. However, don't try to copy every branch exactly. This is impossible and unnecessary.

Notice how sunlight and shadows can help to show form. If you look at the last three tree trunks on the right, you can see how the one that leans over is shown to go behind the extreme right-hand tree and in front of the other one. This was achieved by shading light against dark.

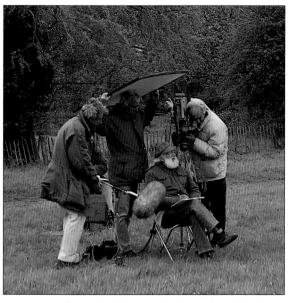

LEFT: *This photograph was taken before we abandoned the sky sketch, below.*

wind, and any other information he felt would help him at a later date. On one, for instance, he wrote: '5th of September, 1822. 10 o'clock, morning, looking south-east, brisk wind at west. Very bright and fresh grey clouds running fast over a yellow bed, about halfway in the sky. Very appropriate to the Coast of Osmington.'

On the opposite page are two of the cloud studies that Constable painted. The first was done in September 1821, and the one below in September 1822.

John Constable had a considerable knowledge and experience of the East Anglian skies. He had studied them while working in his father's mill, as part of his miller's training.

A PAINTER'S PROGRESS

One can see just how much Constable respected the sky in a landscape by the amount of time he spent studying and practising painting it in all its many different moods. He once responded to someone who was disappointed in his own progress as an artist by saying: 'If you had found painting as easy as you once thought it, you would have given it up long ago.' Wasn't he right? We are all still learning every time we pick up a brush!

CLOUD STUDIES

Constable made about a hundred small cloud studies during the years 1821 and 1822, and the majority of these were done in oil on thick paper. He would date each of them, on the back, adding the time of day, the direction of the

LEFT: **Rainclouds over the meadows.**
Alwyn Crawshaw
3B pencil and watercolour on cartridge paper, 20 × 28 cm (8 × 11 in)
I started this sky sketch under camera, and had almost finished when it started to pour with rain. Although I completed it, sheltering under an umbrella, we didn't continue with the filming. This was one that got away. Mind you, if you are trying to paint heavy rainclouds, what can you expect! I worked with a 3B pencil, and used it to put a lot of shading into the sketch.

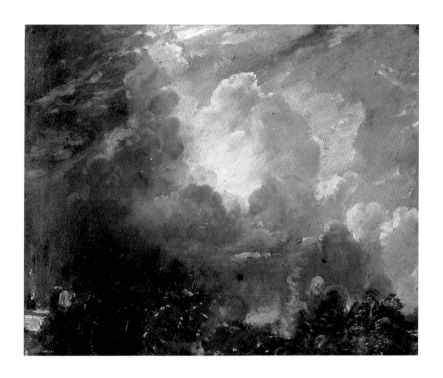

Cloud Study with Tree Tops and Buildings. *Constable 1821*

Oil on paper 24.8 × 30.2 cm (9 ¾ × 11⅞ in)

Private collection of Mr and Mrs David Thomson

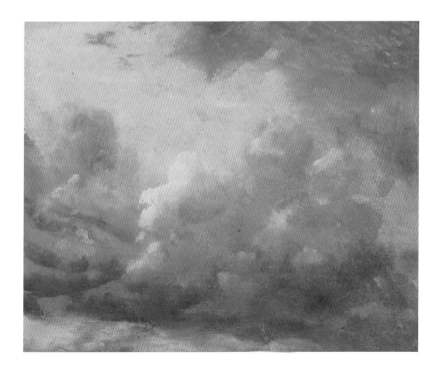

Cloud Study. *Constable 1822*

Oil on paper 24.4 × 30.7 cm (9⅝ × 12⅛ in)

Private collection of Mr and Mrs David Thomson

The meadows around Flatford and Dedham are perfect for practising painting skies. In a travel article on East Anglia, I once saw Suffolk and Norfolk described as 'one inch of land to miles of sky', and I think that this is a very apt description!

In the right kind of weather, you could sit all day, painting different cloud formations and learning about the sky's ever-changing moods.

ABOVE: *On this occasion I managed to complete a sky study for television, shown right.*

It rarely stays the same for very long! I have always believed that the sky is the key element in a landscape painting, and whether it is stormy, cloudy, clear or otherwise will dictate the atmosphere in the rest of the picture. So it is very important to get the sky correct.

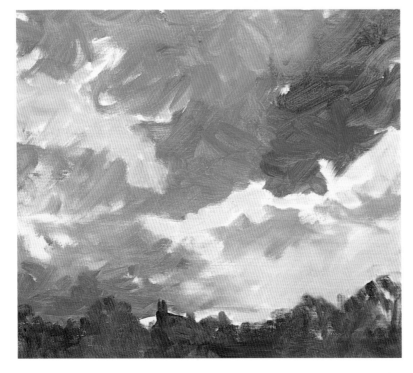

LEFT: **Clouds.** *Alwyn Crawshaw*
Oil on sketching paper,
25 × 30 cm (10 × 12 in)
This surface is good for quick sketches as it allows the oil paint to spread easily. With constantly- changing cloud formations, speed is essential so, when painting a sky sketched from life, mix the main colours on your palette before you start. With this sketch, I began at the top right-hand cloud and worked to the left and down to the trees. The light-coloured sky was left as unpainted white paper. Then I painted over most of this unpainted paper, adding plenty of Titanium White to the colours that were already mixed on my palette.

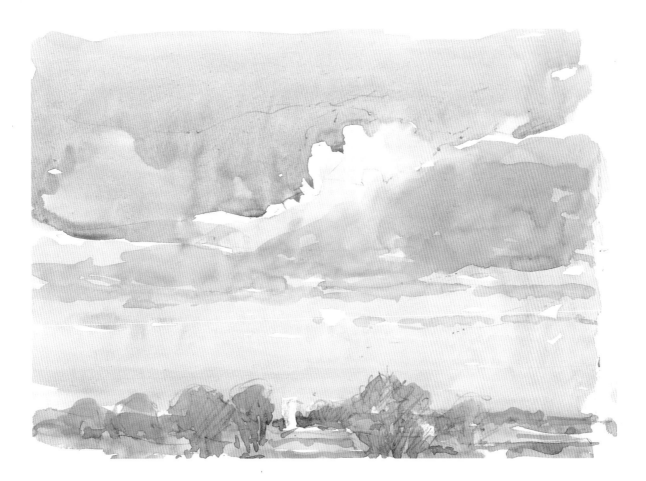

ABOVE: **The last bright cloud.** *Alwyn Crawshaw*
Watercolour on cartridge paper, 20 × 28 cm (8 × 11 in)
For this sky study, I started by drawing in the clouds and the land very simply, with a 2B pencil. Notice how the grey wash, painted into the 'blue' area while it was still wet, ran into the blue, giving the impression of falling rain. When all this was dry, I added some darker areas under the white cloud.

After that, I stopped fiddling – spontaneity is what makes a sketch like this work, although you must always be prepared for this type of exercise to let you down, especially with watercolour. This happens to all of us, but remember failures as well as successes teach us how to paint the sky.

When we decided to make a second attempt at filming me doing a sky study, I didn't have to go far to find another good painting spot. Standing in a field, near the river, I simply looked for the best sky composition, sat down, and was ready to start work on my sketch, shown above.

Unfortunately, very soon the clouds started to merge and created a grey blanket effect in the sky, but I did manage to catch one bright bank of cloud before this, too, was covered with grey.

TRY TO SHOW SCALE

Incidentally, I always recommend painting some landscape, no matter how little, into a sky study. The reason for this is that it gives you the position of the clouds in relation to the ground, and it also provides helpful information about scale.

PROGRAMME 5
MILLS AND WATER

'The sound of water escaping from mill-dams, etc., willows, old rotten planks, slimy posts and brickwork. I love such things. As long as I do paint, I shall never cease to paint such places. They have always been my delight.'

John Constable

Walking in and around Flatford Mill is like taking a journey back through time – it is so unspoilt that I kept expecting to bump into John Constable painting one of his favourite scenes! As I have mentioned before, the whole area has been preserved with sensitive care and thought for future generations by the National Trust and the Flatford Mill Field Studies Council. The latter offer a variety of courses there throughout the year, including painting and drawing tuition. What a wonderful place to learn!

THE DRY DOCK REDISCOVERED

A little way upstream from the mill is the dry dock, owned by his father, where Constable painted his famous picture, 'Boat-Building', shown opposite and on page 29. The dry dock was only rediscovered and excavated a few years ago, when the National Trust was doing building work for its nearby teashop, and I hadn't seen it before. So I enjoyed a few moments of nostalgia, standing in exactly the same position that Constable painted his picture.

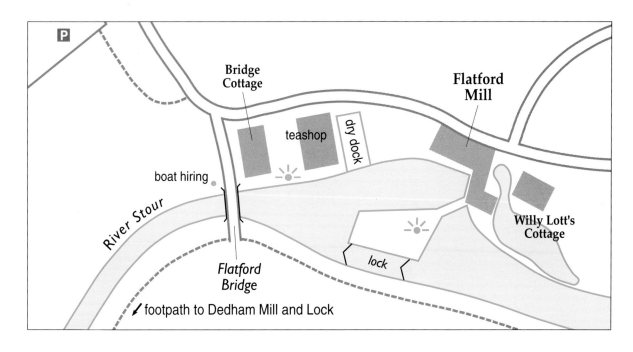

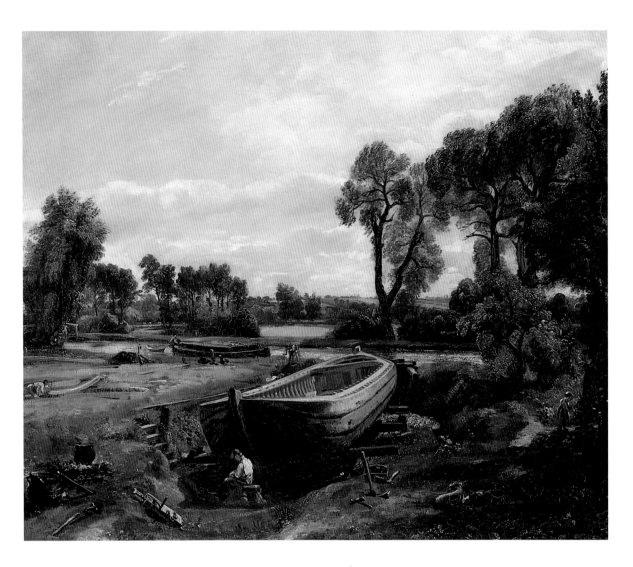

Boat-Building. *Constable 1814–5 Oil on canvas 50.8 × 61.9 cm (20 × 24⅜ in)*
By courtesy of the Board of Trustees of the Victoria & Albert Museum, London

The dry dock as it is today.

My next task was to walk around the dry dock, looking for a pair of moorhens and their chicks! We had spotted these birds earlier and decided to include them in the programme as a quick pencil sketch. Eventually we found them and, for fifteen minutes, tried, in vain, to coax them into position with offerings of bread.

Just then, a family of ducks wandered into the dry dock, and so we decided that I should sketch them instead. June and Mike, the lighting man, kindly kept the ducks from wandering off by continually feeding them, while I was filmed doing my sketch. And after all that, they were edited out of the TV programme but you can see the sketch here in the book.

MOVING SUBJECTS

The result, shown below my sketch of the lock gates at Dedham on the opposite page, is typical of what happens when I sketch birds or animals. Usually my first attempts aren't good (see the duck on the left) but as my pencil becomes more used to the speed at which the subject is moving about, my sketches become more understandable! The duck on the right, drawn seconds later, was a lot better.

When I was art school, I could never have imagined, in my wildest dreams, that one day I would be sketching ducks for television in the dry dock where John Constable had walked and painted two centuries earlier!

BELOW: **Flatford Mill House from the island.**

Alwyn Crawshaw

2B pencil on cartridge paper, 20 × 35 cm (8 × 14 in)

I did this pencil sketch in a few spare moments. Like my pencil sketches of Willy Lott's cottage, in the first chapter, it is a very free drawing. When I came to draw it again later for the camera, I felt that I already knew it and, as always, familiarity with your subject really helps.

ABOVE: **The lock gates, Dedham.** *Alwyn Crawshaw*
Watercolour and 2B pencil on cartridge paper,
17 × 23 cm (7 × 9 in)
This pencil and watercolour sketch is of the lock at
Dedham. I did a lot of shading with a pencil before
I applied the watercolour.

BELOW: **Ducks in the dry dock, Flatford.**
Alwyn Crawshaw
2B Pencil on cartridge paper, 7 × 15 cm (2¼ × 6 in)

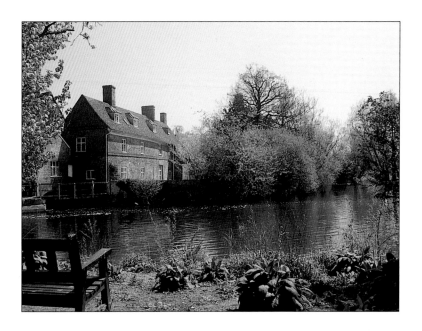

Returning to Flatford Mill, I walked round to the back of the building, where there is a wonderful view of both the mill and the mill house. This is now the gardens of Flatford Mill Field Centre. John Constable sketched and painted this particular view many times.

SERIES OF SKETCHES

The oil sketch, 'Flatford Mill from the Lock', shown opposite, was the last of a series of six sketches that Constable did, all from around the same position.

He used this sketch for the finished painting, shown below it, which was his main exhibit at the Royal Academy in London in 1812. Although traces of the red-jacketed man from the oil sketch can still be seen on the surface of the finished painting, Constable obviously decided to paint him out, and put in the boy fishing in his place in the final version.

FULL OF INSPIRATION

The spot from which I chose to paint the mill house (see page 74) was on the left of the lock, and not on the right, where Constable had worked from. It was a glorious spring afternoon when I did this painting, with the

ABOVE: *Flatford Mill today. It can hardly have changed since Constable stood here.*

sun streaming down, and just a slight breeze (see the photograph below).

Now I know why Constable painted Flatford Mill so many times. The warm red bricks of the building reflected in the slowly-moving water combine to make a scene that is full of inspiration for a painter.

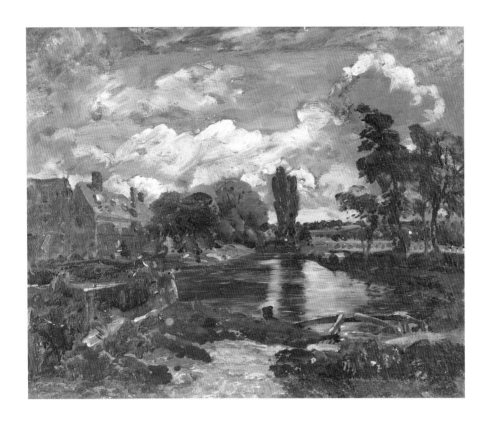

Flatford Mill from the Lock. *Constable ?1811 Oil sketch on canvas 24.5 × 29.5 cm (9⅝ × 11⅝ in)*
By courtesy of the Board of Trustees of the Victoria & Albert Museum, London

Flatford Mill from the Lock. *Constable 1811–12 Oil on canvas 63.5 × 90.2 cm (25 × 35½ in)*
Private collection of Mr and Mrs David Thomson

Flatford Mill House from the island.

Alwyn Crawshaw

Watercolour on cartridge paper,

28 × 43 cm (11 × 17 in)

The mill house is red and this concerned me a little, since this colour would be the key to the whole picture, and if I made the red too dark on the sunny side of the building, the painting would lose its brightness. So I took time to consider the tonal values and the colour of the building very carefully before I painted in the light red wash on the mill house. I knew that when I put the dark shadows on the building, it would give more contrast. This worked and I was happy with it.

As with the painting of Willy Lott's cottage on page 22, the water was a very important part of the painting. If this didn't look right, it would ruin everything that I had already painted, so slight twinges of panic started to set in!

However, once I had decided to paint it in the same way as the water in that earlier painting, I felt better. Planning how you are going to paint water is important. I sometimes go over the area I am thinking about with my (dry) brush, as if I am actually painting it. This is a useful confidence-booster, so do try it. Then mix your washes, take a deep breath, and start painting!

A Lock on the Stour/Boys Fishing. *Constable 1813 Oil on canvas 101.6 × 125.8 cm (40 × 49½ in)*
Anglesey Abbey, The Fairhaven Collection (The National Trust)

The view as it is today.

Look at Constable's painting, 'Flatford Mill from the Lock', on page 73, and locate the point from which he painted the mill house. Then imagine turning around to look in the opposite direction. The view would be the one he had for his painting, 'A Lock on the Stour/Boys Fishing', shown above. What a wonderful place this area must have been for an

artist to grow up in, especially someone who felt as close to nature as John Constable did.

BOYHOOD MEMORIES

I should imagine that, when he did this painting, Constable was remembering his own boyhood, spent playing around Flatford Mill. Perhaps, in his mind, he was one of those lads,

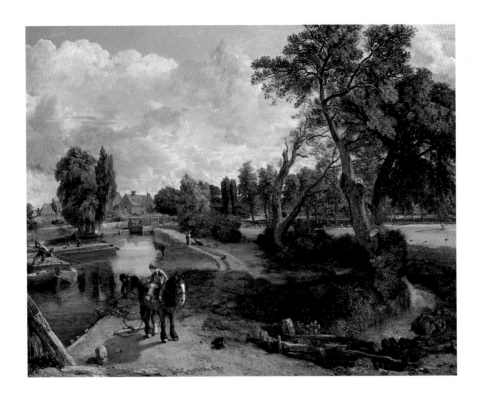

Scene on a Navigable River (Flatford Mill). *Constable 1816–17 Oil on canvas*
101.7 × 127 cm (40 × 50 in) Tate Gallery, London

The view as it is today.

fishing with his friends. The scene has changed considerably now – the lock has been replaced, and trees have grown up on the right-hand side of the path. However, Bridge Cottage is still there in the distance, and the wooden bridge (Flatford Bridge), although not the one Constable painted, is an almost exact replica.

Constable painted 'Scene on a Navigable River (Flatford Mill)', shown above and also on page 31, from the foot of this bridge, looking downstream towards the mill. In fact, you can just see a post from the bridge in the left hand corner of the painting. Because trees didn't line the banks, as they do now, Constable had a clear view of the towpath and mill in his day.

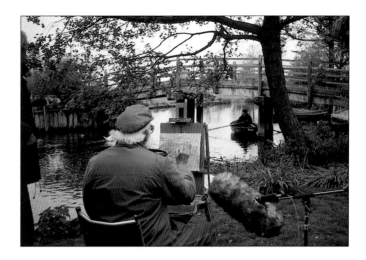

I introduced this programme while rowing myself upstream from Flatford Mill towards the dry dock. In Constable's time, the dry dock was used for building and mending the barges that carried his father's goods from the mill down the Stour, but the river is really only used nowadays by rowing boats.

RIVER VIEW

It was decided that, since there were no barges to paint, I would do an oil sketch, for television, of one of the rowing boats, with Flatford Bridge in the background. I looked around for a river view and decided to paint my sketch from the tiny garden that belongs to the National Trust teashop.

A boat was organized, with someone to sit in it and row it around the bridge area, and I must say that the image of the man in the boat and the wooden bridge silhouetted against the brightness of the water really inspired me.

WORKING DISTRACTIONS

The painting spot I had chosen was a good one for both myself and the cameraman, but the soundman had quite a few problems while recording because of the noises of the teashop, with people chatting, teacups clinking and the squeals of an excited child feeding the ducks!

RIGHT: **Flatford Bridge from the teashop gardens.**

Alwyn Crawshaw Oil on primed hardboard,
25 × 30 cm (10 × 12 in)

I painted the bridge, the boat and the reflections with a dark turpsy mix of Cobalt Blue, Crimson Alizarin and Yellow Ochre, then put in the green field in the distance. I used Titanium White, mixed with a little Cobalt Blue, and some of the colours already mixed on the palette, to paint in the water. Although I worked this very freely, I went carefully round the shape of the boat and man.

The object of a sketch like this is not to record detail, but to capture a special moment that inspires you. Painting directly from nature like this helps to build up your reserves of knowledge for when you work back in the studio.

Mind you, Constable probably had his share of distractions when sketching outside. Two hundred years ago, this was very much a working environment and, no doubt, he would have been asked to move out of the way occasionally, to let the daily work carry on unhindered – although being the son of the owner of Flatford Mill probably wouldn't have done him any harm!

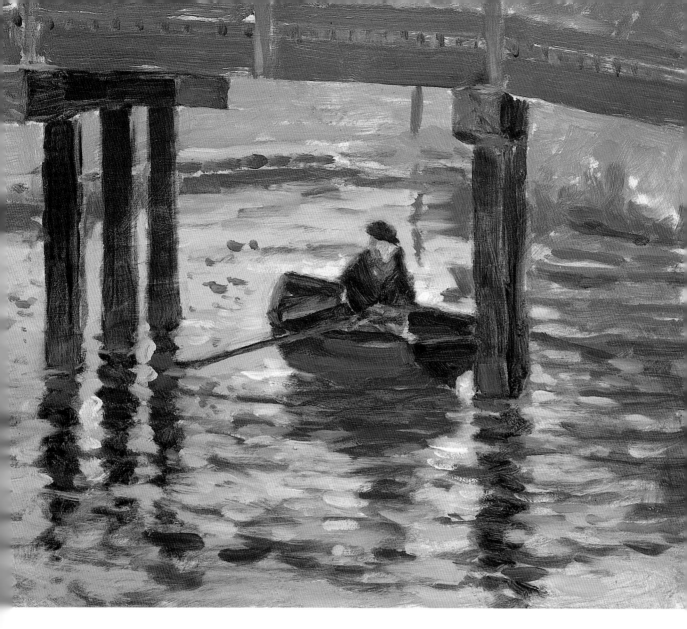

RIGHT: *In this close-up detail, you can see how carefully I worked round the boat and the man. Even so, the brush strokes were done very loosely. I haven't put any detail into the man's face, which has been left the colour of the underpainting.*

PROGRAMME 6
LANDSCAPES

'I shall return to Bergholt, where I shall endeavour to get a pure and unaffected manner of representing the scenes that may employ me. There is room enough for a natural painture. The great vice of the present day is bravura, an attempt to do something beyond the truth.'

John Constable

Constable wanted to be a 'natural painter', portraying the landscape as he saw it. In his youth, his good friend, John Dunthorne, the local plumber and glazier, who was an amateur artist, encouraged him and took him on sketching trips around the Stour Valley.

SOUL-SEARCHING

In 1802, Dunthorne received a letter which reveals some of the soul-searching John Constable did on the subject of landscape painting. Constable wrote, 'For these few weeks past, I believe I have thought more seriously of my profession than at any other time of my life ... For the last two years, I have been running after pictures, and seeking the truth at second hand. I have not endeavoured to represent nature with the same elevation of mind with which I set out, but have rather tried to make my performances look like the work of other men.' He concluded: 'Fashion always had, and will have, its day; but truth in all things only will last, and can only have just claims on posterity.'

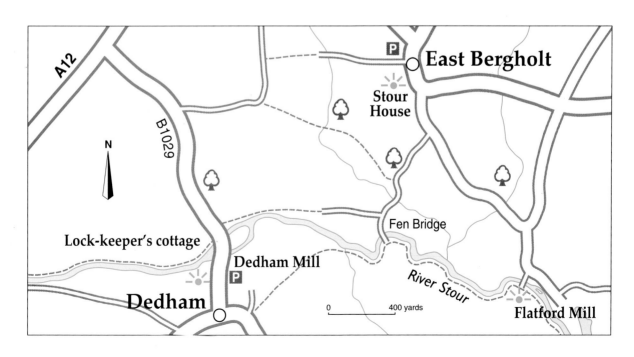

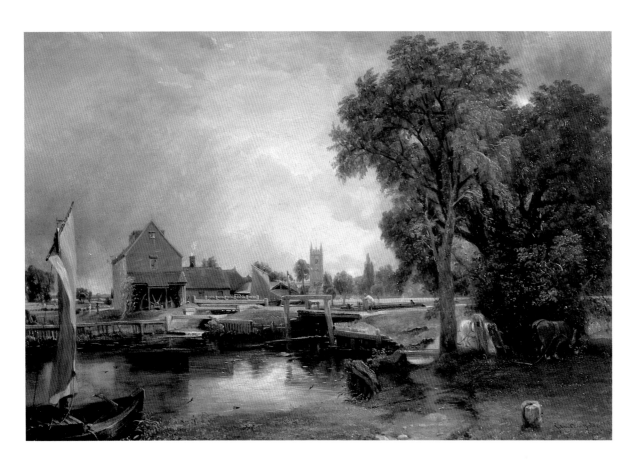

Dedham Lock and Mill. *Constable 1820*

Oil on canvas 53.7 × 76.2 cm (21⅛ × 30 in)

By courtesy of the Board of Trustees of the Victoria & Albert Museum, London

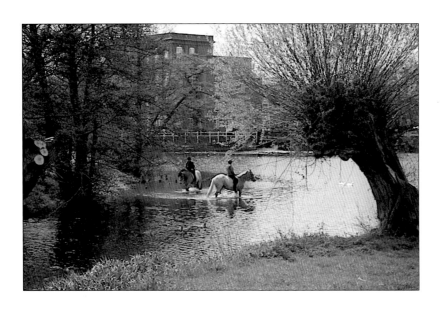

This photograph shows the view as it is today.

81

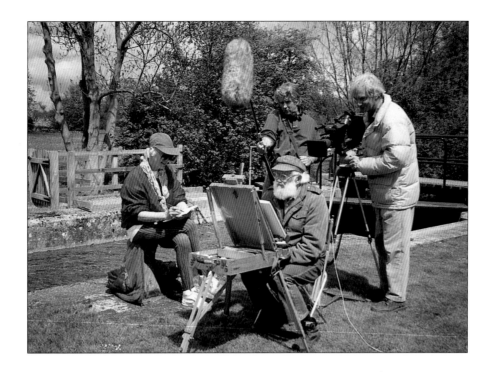

ABOVE: Painting the lock-keeper's cottage at Dedham.

A few days before we started filming the television series, I wandered around Constable Country with June, and we did some sketching.

INTERESTING SUBJECTS

Apart from marvelling at how unchanged and unspoilt the area was, exploring it showed me just how many different landscape subjects it offers, from long-distance panoramas of the Stour Valley to intimate close-up views of country lanes. Then there's the river, teeming with wildlife, and, of course, villages, churches and mills, with all their interesting little corners to paint.

STILL PAINTABLE

Dedham Mill has probably changed the most over the years. It was rebuilt in Victorian times, and has now been converted into flats. You can no longer see the church behind the mill, and the weir and the lock have both been replaced. Constable's painting, 'Dedham Lock and Mill', reproduced on the previous page, shows what it looked like in his day.

As you can see from the photograph below it, the area is still very paintable, although I find the new mill rather a solid structure for my brush.

THE LOCK-KEEPER'S COTTAGE

One charming addition to Dedham Lock since Constable's time is the lock-keeper's cottage. This sits at the head of the lock in a very cosy spot, with trees sheltering it on one side, and the river and a typically English garden on the other.

I felt inspired to paint the cottage from the first moment I saw it, so it was decided that I should do a watercolour of it in this last programme. My painting is shown overleaf.

LEFT: **Trees at Flatford Mill.**

Alwyn Crawshaw

Oil on canvas panel,

23 × 12.5 cm (9 × 5 in)

I did this sketch at Flatford Mill when we were looking for locations. The large tree, not yet fully in leaf, and the water inspired me. Notice how I painted definite brush strokes of sky colour up to the main trunk of the large tree, to emphasize its shape.

The lock-keeper's cottage, Dedham Lock.

Alwyn Crawshaw

Watercolour on cartridge paper,

28 × 43 cm (11 × 17 in)

The most important part of this painting was the preliminary drawing. I was particularly concerned about establishing the cottage and the angles on the sides of the lock. Once these were in position, the trees, the fence, the gate, and all the other details went into place relatively easily.

I put very little detail into the sky and the distant trees but, when I drew in the chimney stacks on the cottage, I suggested a little brickwork on them with my pencil. When I painted them, I used horizontal brush strokes to portray the bricks. You can still see the pencil showing underneath.

As usual, I had to make a decision about the water! Most of the time that I was working, it looked very dark in colour, apart from the reflections, and I felt that this wouldn't help the painting. On two brief occasions, however, the water did go lighter – perhaps because the wind was causing ripples in it. So I decided I would paint it light and not dark.

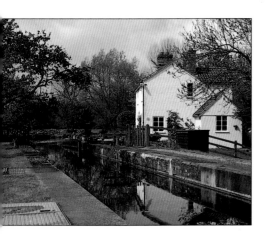

Dedham Vale was particularly significant for John Constable throughout his life. He is recorded to have said that every recollection associated with the Vale of Dedham must always be dear to him because it was among its scenes that the happy years of the morning of his life were passed.

FORMATIVE YEARS

As we know, Constable grew up in and around Dedham Vale. He walked to school across its meadows, played along its riverbanks throughout his formative boyhood years, worked there as a miller for his father, and sketched and frequently painted there during his leisure time.

Once he was allowed to take up art as a full-time profession and moved to London, John Constable still returned to the Stour valley every summer for more than fifteen years, walking daily and sketching obsessively. 'I almost put my eyes out with that practice', he wrote later.

'SWEET FIELDS'

Constable must have also walked around Dedham Vale many times with his future wife, Maria, during their seven long years of courtship. In a letter to her from East Bergholt in 1812, he wrote: 'From the window where I am now writing, I see all those sweet fields where we have passed so many happy hours together.'

So it is not surprising that Constable chose Dedham Vale as the setting for his first large-scale exhibition painting, shown opposite. The scene must have been a very nostalgic one for him since, on his way to school each day, he would have followed the route taken by the figures at the right of the painting and, turning down Fenbridge Lane, passed through the gate that the red-jacketed boy is closing.

Constable exhibited the painting at the Royal Academy in London in 1811, at the age of 35, hoping that it would establish him as a successful artist. He had applied to become a member of the Royal Academy in the previous year.

NOTICED BY FEW

However, the painting was not hung in a very good position in that year's exhibition, and not many people noticed it. As a result, Constable felt that he had fallen from favour with members of the Academy. The one thing that he craved was academic respectability and this was a privilege denied to him for most of his life. In fact, John Constable wasn't elected an Associate of the Royal Academy until 1819, aged 43, and didn't become a full Royal Academician for another decade, just eight years before his death.

When I was at art school in Hastings, I thought that Constable had been at liberty to paint whatever and whenever he wished. I also assumed that he had been a venerated member of the Royal Academy for most of his working life. After all, he was 'the Master' of English landscape art.

DOMESTIC PROBLEMS

The truth is that, although he was an artistic genius, John Constable was also an ordinary man, often suffering for his art. He was even, like most of us, vulnerable to domestic problems! I was interested to note that, in a letter to his closest friend, John Fisher in 1822, Constable wrote: 'We left Hampstead a fortnight ago last Friday, and I have not yet had my pencil in my hand. I got laid up attending bricklayers and carpenters at six and seven in the morning, leaving a warm bed for cold damp rooms and washhouses, for I have had immense trouble to get the house habitable.'

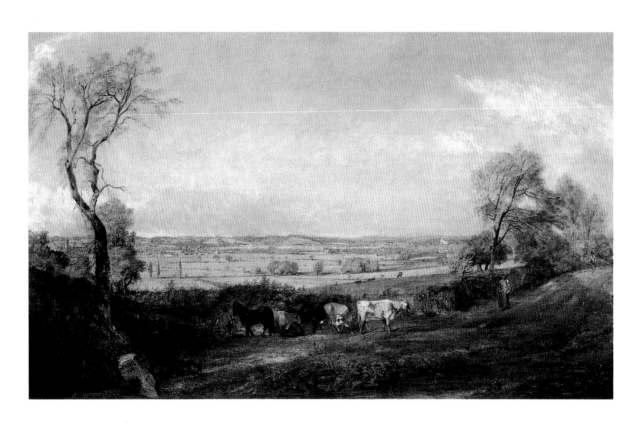

Dedham Vale: Morning. *Constable 1811 Oil on canvas 78.8 × 129.5 cm (31 × 51 in)*
Courtesy of the Elton Hall Collection

One of the best vantage points from which to see Dedham Vale is at the rear of Stour House, in East Bergholt, just across the road from where Constable lived as a boy. I felt that this would be the perfect place from which to paint my final picture for television, looking over the valley that John Constable loved so much and close to the spot where I had started my travels in the series.

WONDERFUL VIEW

The house used to be known as West Lodge, and the people who owned it then were good friends of the Constable family. During his painting years, John Constable painted both the house and the views from it.

I was very fortunate, because the present owners of Stour House gave me permission to paint the wonderful view over Dedham Vale from their garden.

There was a lot of thick, heavy cloud in the sky on the morning that I did my painting. The sun came out a few times, but eventually decided to stay away altogether. However, that didn't deter me, and I really enjoyed doing this picture.

FOCAL POINT

I used Dedham Church tower as a focal point of the painting. From my viewpoint, the top of the church tower finished just slightly below the horizon. Because this would not have made it prominent enough in the painting, I used my artistic licence to make the tower a little taller so that it broke through the horizon and stood proud, as it did in so many of John Constable's paintings.

Later, as I walked out through the gates of Stour House after I had finished the painting, I looked across the road to Golding Constable's garden, where John Constable had played as a child, and where I had filled my lemonade bottle with water from his well (see page 12).

RIGHT AND OVERLEAF: **Dedham Vale from Stour House, East Bergholt.** *Alwyn Crawshaw*
Oil on primed hardboard, 20 × 40 cm (8 × 16 in)

I decided to paint a panoramic view, since I wanted a wide aspect, without too much sky. By having Dedham church tower on the left of the picture, I could see the river in the meadows on the far right. When the sun came out a couple of times, very weakly, I was able to distinguish the shapes of trees out of the general mass of green in front of me.

I painted the trees in the distance, behind the church, in very dark shadow. This was one of the most important decisions of the painting and doing this established the church tower and gave it stability.

When the sun made those brief appearances and livened up the scene with light, I was tempted to alter what I had already painted. However, changing your mind once you have started can be fatal – you risk ending up in 'no man's land'. When nature keeps having mood changes, don't weaken, stay on your original track. I was happy with the painting, and I am sure I will return again to paint the scene when the sun is full out!

It was the perfect place to end a wonderful journey and, once again, I stood for a while, lost in the mists of time. Then I heard June calling, 'Come on, Alwyn, the crew are all packed and we're ready to go'. Back to reality and to the 20th century!

However, I know that it won't be long before we are following in John Constable's footsteps around Constable Country again – and I hope that some day soon, you will be able to do the same.

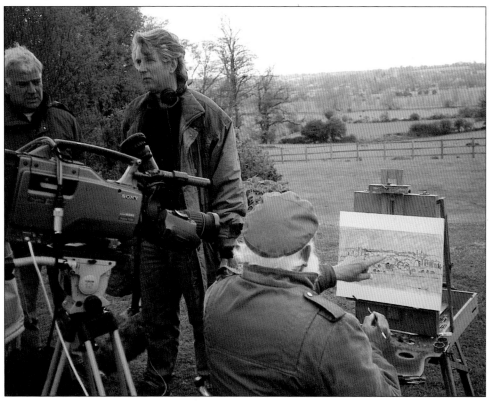

*The first stage is done and I'm about to start painting – I just
wish the sun would come out!*

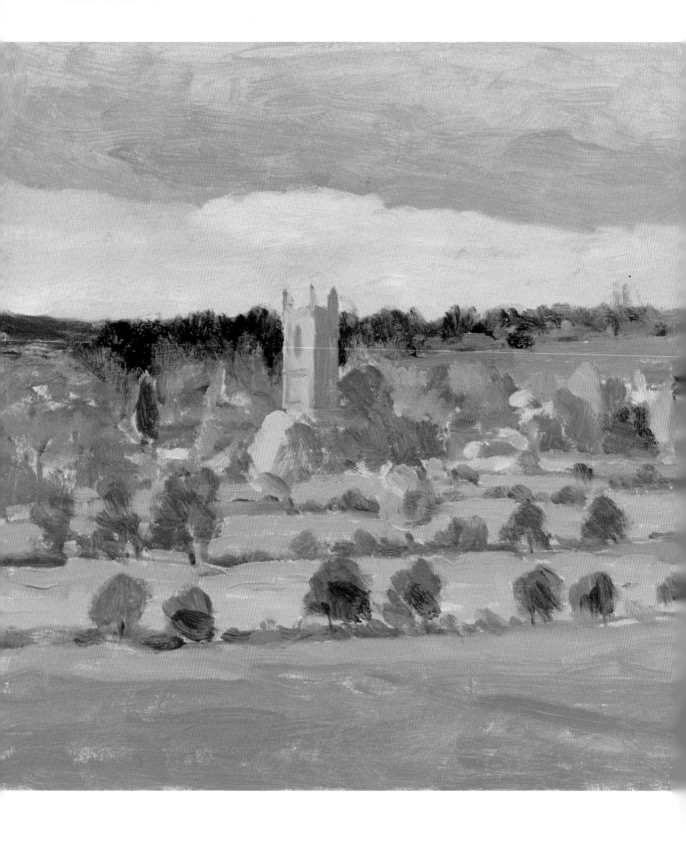

ACKNOWLEDGEMENTS

I would like to record my sincere thanks to Cathy Gosling from HarperCollins, to Flicka Lister for designing and editing this book, and also to Mary Poole for typing the manuscript.

I would also like to express my gratitude to the producer and director, David John Hare, and the members of the television crew, Richard Crafter, Eddie Elmhirst and Mike Rogers, as well as Paul Freeman, Graham Creelman, John Swinfield, Joanna Mytton, Dave Robbins and Paddy Burns from Anglia Television.

Many thanks are also due to the people who helped us so much during the making of the television series: to Mr and Mrs Thomson, Leslie Parris, Paul Milsom, Marion Barwell and all at the Maison Talbooth, John Le Mare, Mary and Derick Thornton, East's Garage, the National Trust at Flatford and Flatford Mill Field Centre, George Curtis, Reverend Gerard Moate, Reverend John Druce, Reverend David Finch, David Tripp, Murray and Debbie Aitken, Mr and Mrs Wallace and Wendy Parkinson.

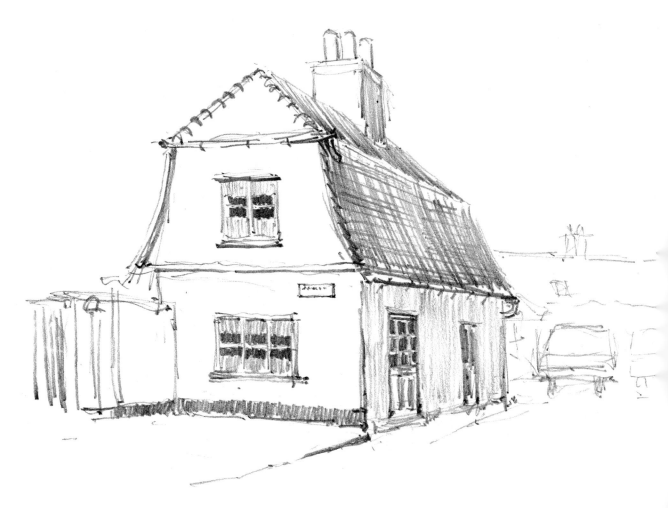

INDEX

Page numbers in **bold** refer to illustrations